MORE
MURDEROUS
BOLTON

MORE MURDEROUS BOLTON

STEVE FIELDING

AMBERLEY

First published 2010

Amberley Publishing Plc
Cirencester Road, Chalford,
Stroud, Gloucestershire, GL6 8PE

www.amberley-books.com

British Library Cataloguing in Publication Data.
A catalogue record for this book is available from the British Library.

ISBN 978 1 84868 309 9

Typeset in 10pt on 12pt Sabon.
Typesetting and Origination by FONTHILLDESIGN.
Printed in the UK.

CONTENTS

The Author 7

Acknowledgements 8

Research and Sources 9

Note 10

Introduction 11

1 The Man with the Evil Laugh 19

2 The Derby Street Tragedy 21

3 On a Moonlit Night 25

4 A Fatal Three Minutes 29

5 Who Killed Old Reuben? 31

6 The One-Legged Night Watchman 35

7 Inside the Locked House 41

8 Suicide or Murder? 45

9 The Bride-to-be 49

10 Murder on the East Lancs Road 51

11 'In the Canal down Darcy Lever' 57

12 After the Last Dance 65

13 In Desperation 69

14 Vanished Without a Trace 77

15 Streets of Fear 81

16 In Self-Defence 85

17 No Motive or Anything Like That 89

18 His Daughter 95

19 Suspicions and Emotions 99

20 About Another Boy 105

21 Unwelcome Advances 109

22 'Something Serious' 115

23 While Doing His Duty 119

24 Person Unknown 125

Further Reading 128

Author Steve Fielding

THE AUTHOR

Steve Fielding was born in Bolton, Lancashire, in the 1960s. He attended Bolton County Grammar School and served an apprenticeship as an engineer before embarking on a career as a professional musician. After many years of recording and touring, both in Great Britain and across Europe, most notably with punk rock band The Stiffs, he began writing in 1993 and had his first book published a year later. He is the author of a number of books on the subject of true crime, and in particular hangmen and executions. He compiled the first complete study of modern day executions, a three volume set entitled *The Hangman's Record 1868-1964* (Chancery House Press, 1994) and, as well as writing a number of regional murder casebooks, he is the author of two books on the history of the executioner: *Pierrepoint: A Family of Executioners* (John Blake 2006) and *The Executioner's Bible — Hangmen of the Twentieth Century* (John Blake 2007). He is the creator of the History Press' '*Hanged at*' series and has written six volumes so far. *Hanged at Durham* in 2007, *Hanged at Pentonville* and *Hanged at Liverpool* in 2008, and *Hanged at Manchester, Leeds* and *Birmingham* were all published in 2009. *Hanged at Winchester* will be released in the summer of 2010. He has worked as a regular contributor to magazines such as the *Criminologist, Master Detective* and *True Crime* and as the Historical Consultant on the Discovery Channel series *The Executioners,* and *Executioner: Pierrepoint* for the Crime & Investigation channel. He has also appeared on *Dead Strange* (Southern Television) and BBC1's *The One Show.* Besides writing he also teaches at a local college.

More Murderous Bolton is his twentieth book.

ACKNOWLEDGEMENTS

I would like to thank the following people for help with this book. Firstly to Lisa Moore for her help in every stage in the production, but mainly with the photographs and proofreading. I offer my sincere thanks to Matthew Spicer, who has been willing to share information along with rare documents, photos and illustrations from his own collection, and to Janet Buckingham who helped to input some of the original data.

I would also like to thank Bill Leonard for help with a number of the maps and photographs and Bernadette Tither for help with information on a number of cases in the New Bury area. Thanks also to all the staff in the archives and local studies department at Bolton Central Library, past and present, who have helped with information on this and my previous books on local murders and executioners.

Finally I would also like to thank the many readers of the original *Murderous Bolton,* and my other books, for their kind words, along with encouragement and support, and to those people who offered information and suggestions for cases for this second volume of Bolton murders, sorry for the delay and I hope you find it worth the wait.

RESEARCH AND SOURCES

Since the original version of *Murderous Bolton* was published in 1994, there has been, to my knowledge, just one other book detailing crimes in and around Bolton, but this covered much the same ground as *Murderous Bolton* and concentrated predominantly on Victorian cases. No books have covered, to any extent, murders committed in and around Bolton in the twentieth century, and this second volume of *Murderous Bolton* fills that void.

Readers of my other books may notice that one or two of the cases featured in *More Murderous Bolton* have appeared before, in an abridged or edited form. For the record, the story of Reuben Mort (1920) first appeared in *Lancashire Tales of Mystery and Murder* published by Countryside Books in 2005. The stories of William Thorpe (1925) and Jack Wright (1951) both appear in *Hanged at Manchester* (History Press, 2009) and the cases of Jack Wright (1951) and Gordon Lee (1970) both featured in *Lancashire Murder Casebook* (Countryside Books 1994).

New information on all those cases mentioned above has been added to the stories since they were first written and new photographs accompany them.

The bulk of the research for this book was done many years ago and extra or new information has been added to my database as and when it has become available. The material used in the research has been gathered from a variety of sources. In most instances contemporary local and national newspapers have supplied the basic information — all these cases were covered in depth in the *Bolton Evening News* — with most being featured in the provincial and national press. This information has been supplemented by material found in PCOM, HO and ASSI files held at the National Record Office at Kew. Personal information is also held in the author's collection from a number of those involved in, or who recall first hand, some of these cases.

I have tried to locate the copyright owners of all images used in this book, but a number were untraceable. In particular, I been unable to locate the copyright holders of a number of images, in the main those sourced from the National Archives. I apologise if I have inadvertently infringed any existing copyright.

NOTE

In compiling this casebook of local crimes from a more modern era, I am mindful that some people innocently associated with a number of these cases may still be living in the area. I have tried to treat all the cases with respect and sensitivity, reporting only factual material that has appeared in the press and in papers open to the public in the National Archives. I have deliberately not named some people involved in more recent cases if I felt mentioning them by name served no purpose or detracted from the narrative. I must stress that it is my intention to neither cause any upset to anyone alive, nor disrespect the dead, in recounting these stories.

All the cases in this book featured heavily in newspapers of the day and all the information I have used is freely available and in the public domain. In making this a comprehensive study of local murder cases in the twentieth century, I have had to use all the stories contained within, because of their location and date, but I have kept the most recent cases to at least twenty-five years old. Hopefully this will not cause too much upset in revisiting old cases that may still be fresh in the minds of some people; please accept my sincere apologies if this is the case.

Steve Fielding
December 2009
www.stevefielding.com

INTRODUCTION

The twentieth century was to see many sensational murder cases that passed into the annals of crime, along with great strides in technology, many of which were used in the solving of these crimes. It was a century of rapid technological developments, and one of the greatest in the aid of criminal detection was the understanding, usage and acceptance of fingerprint evidence. The first successful murder case solved using fingerprint evidence took place in London in 1905 and fingerprinting has helped solve numerous cases in the following years.

Bolton was a powerful commercial town at the turn of the century with a variety of businesses, but predominantly textiles and engineering. The population grew as workers from across Great Britain moved to the area in search of work, and as they did so crime increased. The town's chief constable at the turn of the century was John Holgate, who had moved into post in 1877, and under his command the local police force was restructured and saw many changes before his retirement in 1911.

Frederick Walter Mullineux replaced him in the role of chief constable and it was during his tenure that the role of the special constable was introduced to aid police in an emergency. It was also during this era that women police officers were introduced, as was a mounted police force and a dog-handling unit, and motorcars were soon utilised by the police forces to help them respond to crimes more quickly.

The duties of the fireman was also re-established in the early twentieth century, clearly separating the role from that of the policeman who until this time had also been responsible for dealing with this type of incident. The early part of the twentieth century also saw the advent of radio communication now used by the police to replace the outdated methods of summoning assistance by striking truncheons on the pavement. It was during the command of Mullineux that Bolton was the subject to bombings from a stray German Zeppelin airship, in 1916, when over a dozen residents were killed during an air raid in the Deane Road area of town.

Fortunately, the town's name tended to make the headlines in newspapers across the country more for its sporting achievements than for the murders committed here, with its football team, Bolton Wanderers, winning the first FA Cup final

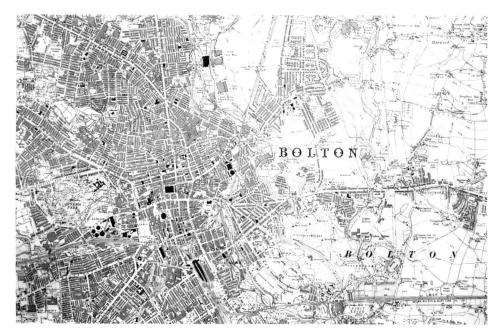

Map of Bolton Town Centre in the early twentieth century

played at the new Wembley Stadium in 1923. Shortly after the war, football again made the headlines, but for all the wrong reasons, when thirty-three spectators were crushed to death at Burnden Park following an FA Cup match in March 1946. A large numbers of supporters gained entry to the ground by climbing over a wall at the back of the terrace or entering through an unlocked gate left open by a spectator leaving early, fearful of the large crowds assembled well before kick-off. Although a full investigation was carried out, no criminal charges were seemingly made against the club.

In the early 1970s, the boundaries across the country were redrawn and Bolton found itself now part of Greater Manchester, and as a result the police force moved from the overall control of Lancashire Constabulary and became part of the Greater Manchester Police.

For a town the size of Bolton it has been comparatively free of infamous murder cases. It is perhaps something of a paradox that whilst being the home of just a small number of convicted murderers, it was the residence of many men paid by the state to take life. At the turn of the twentieth century, the chief executioner in Great Britain and Ireland was James Billington, at this time running The Derby Arms, a public house on Churchgate. Billington carried out his last execution at Manchester's Strangeways Gaol in December 1901 when he hanged one of the regulars at his public house (see *Murderous Bolton*, Amberley Publishing, 2009).

Bolton Magistrate's Court, Mawdsley Street

Billington died from an illness a few days after returning from the execution and was soon replaced by his son William. William was James's second son, and his older brother, Thomas, was also an assistant executioner for a time during the last decade of nineteenth century. It had been William Billington who had been responsible for a shake up in the whole process of recruiting hangmen when in the summer of 1899 he had turned up at Lincoln Prison in place of his father, who had suddenly been taken ill. William lied to the prison governor saying he had already carried out executions on his own, but when he went to make his preparations in the execution chamber the warders sent to assist him could see he was unsure what to do and clearly had little experience in preparing for an execution.

Although he was able to carry out the execution to everyone's satisfaction (except maybe the condemned prisoner's), on the following morning, when questioned by the governor before leaving the prison, Billington admitted he had lied and had only

Left: *Bolton hangman James Billington, the country's chief executioner at the turn of the twentieth century*

Below: *Thomas and William Billington*

*John Billington — died following
an accident whilst preparing an
execution in the summer of 1905*

ever assisted his father in the past. He said he feared if he told the truth the governor
would not have allowed him to carry out the execution!

Following this it was decided that anyone who wished to act as a hangman
had to undergo training, initially at London's Newgate prison. Then, once he had
successfully completed his training, his name would be added to a list of qualified
hangmen. Prison governors were ordered to only employ executioners whose names
appeared on this list.

Two local men, Robert Wade of Chorley New Road and William Warbrick of Pole
Street, both assisted James Billington around the turn of the century, and although
both had been assistants for several years, following training at Newgate in 1901,
neither was deemed suitable to be promoted to chief executioner and soon left the
list. Warbrick was called out of retirement twice to assist at executions, once in 1905
and again in 1910, and published his memoirs in a Sunday newspaper during the
First World War.

Thomas Billington died early in 1902 following a short illness, and William
Billington was sent to prison in 1904 on a charge of deserting his wife, leaving the
last of the family, youngest son John, as the remaining Billington hangman. John

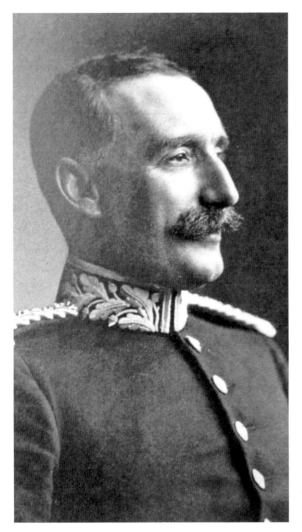

Frederick Walter Mullineaux,
Bolton's Chief Constable
1911-1930

continued as chief executioner until August 1905 when he suffered an accident whilst on duty at Leeds prison. Billington stumbled and fell through an opened trapdoor and suffered injuries to his chest and ribs. He was able to carry out the execution on the following morning but once he returned to his new home at Coppull, he was taken ill and died a few months later.

The next Bolton hangman was Thomas Mather Phillips, a Little Lever collier who applied for the post shortly after the end of the First World War. One of the first executions Phillips assisted at was that of Freddie Bywaters, who along with Edith Thompson had been convicted of the murder of her husband. The case caused massive furore in the press of the day, as many people believed Edith Thompson, who had played no actual part in the murder, was really being hanged for adultery.

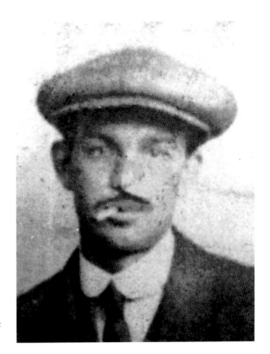

Little Lever collier Thomas Mather Phillips became a hangman in 1922

Hangman Harry Bernard Allen lived in Farnworth and Whitefield in the post war years and was one of the last two hangmen in Great Britain

Phillips, now living at 208 Albert Road, Farnworth, assisted at a number of well-known executions during the 1920s, and in the mid-1930s, he left Farnworth and settled in North London. In 1939, he was promoted to the position of a chief executioner and carried out a handful of hangings before he was dismissed following a drunken outburst prior to an execution at Wandsworth in the spring of 1940. He returned to the North West and died at his new home in Rochdale exactly one year to the day since carrying out his last execution.

Another hangman of the 1920s was George Brown who for a time lived on Halton Street, in the Haulgh district of Bolton, and in the 1940s, assistant hangman Harry Allen took over the running of the Rawsons Arms in Farnworth. Allen later moved to the Junction Hotel at Whitefield and while living here he assisted at the hanging of Derek Bentley in 1953, in one of the most controversial executions in the post war years.

Following the resignation of chief executioner Albert Pierrepoint in 1955, Harry Allen went on to become one of the last two executioners in Great Britain. He hanged A6 murderer James Hanratty in 1962 in one of the most famous cases in modern times, and he carried out one of the last executions in August 1964 when he hanged one of two men convicted of a brutal murder in Cumbria. At the same time Allen was on duty at Manchester, fellow executioner Les Stewart of Chadderton carried out the execution of the other man at Liverpool.

This casebook looks in detail at almost every murder committed in Bolton and the surrounding area from the beginning of the twentieth century until the early 1980s. When a suitable time has passed, a further volume, covering more modern cases, may well appear.

CHAPTER 1

THE MAN WITH THE EVIL LAUGH

Almost everyone who knew George Thompson commented on his laugh. Not the normal jocular chuckle, Thompson's was a sinister, almost 'evil' laugh. Fond of playing practical jokes on his friends and workmates, Thompson would end each prank with a sly grin, followed by his signature laughter. There were, however, a number of people who believed that Thompson's laugh was hiding something more sinister than just a wicked sense of humour.

Forty-four-year-old Thompson had married his second wife, Elizabeth Monks, in December 1904 and they occupied a house at 32 Clifford Street, off Blackburn Road, Bolton. His new bride, some eight years older, had been recently widowed, and for her it was her third marriage. They shared the house with her two children, an eight-year-old boy and a fourteen-year-old daughter, Annie Monks. The marriage, however, was not a happy one, due in the main to the jealousy Thompson had for his wife, although it seemed that there was nothing to cause him to have these feelings.

Elizabeth Thompson was a popular and well-respected figure in the neighbourhood and earned her living making and selling herb beer, which she brewed in the kitchen of her home. On Tuesday 1 August 1905, she spent much of the afternoon gathering up the materials she would use in the brewing and retired to bed at the usual time once darkness had fallen. The children had also retired to bed and shared a room together at the back of the house.

Thompson worked as a fire-beater at Messrs Eden and Thwaites bleach works on Meetings Lane, and shortly before dawn on the following morning he left the house and made his way to work. Even though dawn had yet to break properly it promised to be a bright summer's morning as Thompson approached the mill. A workmate walking a few yards behind Thompson watched as he approached the bridge that spanned the mill lodge, then saw him remove his jacket throw it down onto the embankment before throwing himself off the bridge into the lodge.

The worker hurried to find a policeman and soon police sergeant Thomas White along with constables Marples and Murphy hurried to the scene. Thompson was already floating face down in the water. Sergeant White noted the time as 5.10 a.m.

when they arrived at the lodge and after obtaining some grappling hooks from the mill they set about pulling the man from the water. By 5.30 a.m. they had removed the lifeless body of George Thompson from the lodge.

In the meantime, back at the house on Clifford Street other officers were present after the screams of fourteen-year-old Annie had alerted neighbours who had entered to find that a murder had taken place. Elizabeth Thompson lay dead in her bed and in the bedroom were signs of a struggle: a chair was knocked over and there was bedding on the floor. Doctor Thomas Boulton was summoned and noted that there were signs of bruising around the woman's head as though she had been beaten with a heavy, blunt instrument.

A short time later Thompson's body was carried from the lodge and laid in the front room of his home where Dr Boulton confirmed that death had been due to drowning.

An inquest was held on the following afternoon in the Bowling Green public house. Chaired by coroner J. M. Rutter, evidence was heard from the daughter Annie, who claimed she had heard no signs of any fight on the night of the murder. She told the inquest that the family lived comfortably but her mother and stepfather did quarrel a lot and that some weeks before she had heard him make threats to 'throttle her'.

The short inquest ended with the jury finding that Elizabeth Thompson had been feloniously killed and that George Thompson had then committed *felo de se*.

A neighbour told reporters that it was a 'blessing he had left the children — they were afraid of him.' Another, discussing the pranks that Thompson would often play, was more forthright: 'I thought that fiendish laugh was a sign of insanity.'

FELO DE SE

Taken from the Latin for 'felon of himself', *felo de se* is an ancient legal term literally meaning suicide. In early common law, an adult who committed suicide was literally a felon, and that crime was punishable by the forfeiture of their property to the king. The felon would also be condemned to a shameful burial — typically having a stake driven through his heart and the body buried at a crossroads. A child or anyone considered mentally incompetent person, who commited suicide was not considered a *felo de se* and was not punished after death. The term is no longer commonly used in legal practice.

CHAPTER 2

THE DERBY STREET TRAGEDY

In the early part of the twentieth century, the side streets and alleyways at the bottom of Derby Street, a few minutes' walk from the town centre, on the road leading out towards Atherton and Leigh, were described as a grim neighbourhood, where disease and crime went hand in hand, and where hardship and poverty was a way of life. Built in the shadows of numerous dark, imposing cotton mills, with belching chimneys that reached high into the smoggy sky, and bordered by miles of railway lines, sidings, coal and goods yards, its population comprised mainly of mill-workers, miners and labourers.

Amongst a host of identical terraced one-up, one-down houses standing in grim rows, forty-year-old Preston labourer Tom Flitcroft and thirty-six-year-old Gertrude Rawlinson, and her three children — whose ages ranged from twelve years to twelve months — made their home at 5 Back Bristol Street, a few weeks before the annual June Wakes holiday in 1911.

This was a place populated by criminals, where quarrels and domestic violence were the norm. Houses often had windows covered with cardboard or boarded up, smashed after a drunken quarrel. It was an area of squalor, and Flitcroft's house — with the adults sharing a lumpy flea-infested bed in the solitary bedroom and with the three children sleeping on a bundle of rags in the corner — no different to any other in the area.

Both Flitcroft and Rawlinson, like many of their neighbours, possessed a criminal record. Flitcroft, a former soldier who had fought in the Boer War, had served a prison sentence for failing to pay maintenance payments to his wife in Preston, while Gertrude Rawlinson had found herself before Mr Justice Bucknill at Manchester Assizes in January 1902 charged with concealing the birth of her child. Described then as a housekeeper, she had been indicted with manslaughter. She made an impressive showing in the dock; smartly dressed and repentant she admitted having disposed of the child who had been born prematurely and which the judge told the jury was tantamount to a plea of guilty. She had been sentenced to three months' hard labour and had broken down in tears when sentence was passed.

Shocking Murder in Bolton.

Double Tragedy off Derby-st

Children Eye-witnesses of Terrible Scene.

GRAPHIC STORY BY NEIGHBOURS,

A FIVE HOURS' DEADLY STRUGGLE.

Cutting relating to the Derby Street murder

Even though sounds of quarrels in these tightly packed run-down streets were frequent, neighbours still paid attention to them, and shortly before midnight on 23 November, Mr and Mrs James Perry, who resided at number three, heard sounds of cursing and shouting from next door. When this continued into the early hours of Friday — having now lasted over five hours — they finally began to suspect that something was amiss. The shouting eventually subsided but when they began to hear sounds of banging they believed that burglars may be at work and went to investigate.

Finding the back door unlocked, James Perry entered the house and found a horrific sight: there was blood splattered along the walls and lying on a sofa in the kitchen lay Gertrude Rawlinson, who had been battered to death and her throat cut. Close by, Thomas Flitcroft was sitting on an up-turned bucket, half naked and with a self-inflicted throat wound. He died from his wounds before assistance could be given. In the bedroom a terrified twelve-year-old Madge Rawlinson told the neighbour that 'Tommy's cut my mother's throat, and then cut his.' An ambulance was soon summoned, and while Madge and the two young children were taken to a relative's, the two bodies were removed to the mortuary at Bolton Royal Infirmary.

An inquest was fixed for the following Monday where, before coroner Mr J. Fearnley, a motive for the horrific tragedy was suggested to the court. It was learned that Flitcroft had taken Gertrude and her children in when her former boyfriend had

been sent to prison, leaving her homeless and on the streets. Although they had frequently quarrelled there seemed to be a good deal of affection between the couple and it seemed that Flitcroft, a heavy drinker, who often went into a frenzy when drunk, had become jealous at the impending release from prison of her ex-boyfriend, and believing she was about to leave him for her ex, they had quarrelled. It had ended with him cutting her throat before turning the razor on himself.

The court also heard that Flitcroft, who worked as a roofer and slater's labourer, was suffering from a form of insanity and more than one of his fellow workers had humorously claimed that he 'had a slate loose!'

The house on Back Bristol Street

CHAPTER 3

ON A MOONLIT NIGHT

Albert Unwin had first met Eliza Osborne while he was working at a colliery at Moorthorpe near Doncaster in South Yorkshire during the summer of 1915. Eliza's husband, also called Albert, had enlisted into the East Yorkshire regiment in September 1914, shortly after the outbreak of the First World War, and when in the following July he was wounded in action and sent home for treatment, his wife told him she had taken in forty-one-year-old Unwin as a lodger.

Osborne seemed to accept that Unwin was a genuine lodger and that nothing untoward was going on at the house, and once he had recovered sufficiently enough to be sent back to his unit in France, he bade them farewell and departed. Within three weeks he was back in Yorkshire on compassionate leave following stories that had reached him that Unwin was having a relationship with his wife. He confronted them and a fierce quarrel ensued and as a consequence Unwin and Mrs Osborne moved out of the house and took new lodgings with Unwin's brother in Rotherham. After living together as man and wife for two months, Eliza decided to return to her mother's house at Radcliffe, and along with her two sons, ten-year-old Horace and six-year-old Albert, she crossed the Pennines and returned to her place of birth.

Unwin soon followed and they took possession of a house at 3 Back Edward Street, while the boys both enrolled into the nearby St John's school. Things, however, did not go well for Unwin and Mrs Osborne and they began to quarrel frequently. As a result they parted; Unwin returned to Rotherham while Eliza took her boys and moved back to her mother's at nearby Bowling Green Street.

At Christmas 1915 Unwin returned to Radcliffe where he now discovered that while he had been away Eliza had taken many of the items they had bought to furnish the house, while the hire purchase company had repossessed other things they had purchased. He took lodgings nearby and saw Eliza every day but she refused his frequent requests to live together.

In early January 1916, things between them had become so tense that whenever she saw Unwin approaching she tried to hide from him. On Monday 17 January, Unwin saw Eliza in the street and when he went to talk to her she turned on her heels and

fled. In a rage, he vowed he would get even with her and decided on a dreadful course of action.

On the following morning the boys left their grandma's house at shortly after 8 a.m. and headed for school, reaching there at 8.45 a.m. At lunchtime Horace and Albert shared lunch together and a short time later they noticed Unwin standing at the school gates. He called them over and said that he had received word that their father was due at Bury railway station that evening at 5 p.m. He said that Albert Osborne had sent word he was back in Blighty and his unit were heading towards Manchester and would be passing through Bury. He said that their mother had given permission for Unwin to take the boys out of school and as she couldn't make the trip to the station she had asked Unwin to do so.

At 3.30 p.m., Unwin returned to the school and, after speaking to the headmaster, he collected the two boys, and they were seen heading towards New Road where they walked towards Whitefield before catching a tram to Bury. Unwin took the boys into a café where he bought them both a cup of tea and a buttered teacake, and at 5 p.m. they waited on the platform. Albert Osborne was not on the train nor was he on the next or the one after that. Deciding that there must have been a change of plans, and with darkness now having fallen, they left the station. After waiting in the street for a short time, Unwin took the boys to the Art Picture Hall.

They left the hall at 8.30 p.m. and made their way home, but instead of retracing their steps Unwin told the boys he knew a short cut and they made their way through fields heading towards Outwood Colliery. They passed a reservoir where Unwin grabbed the young Albert and made to throw him into the water. When the young boy began to cry Unwin said he was only playing and they continued on their way. Horace was becoming increasingly worried that something was amiss and seeing a woman standing outside her house he asked her to tell them the correct road to Radcliffe. She directed them to go over the bridge and onto Mount Sion Road from where Horace would be able to find his way home. It was then, as they crossed the River Irwell and reached Shakey Bridge that spanned the Bolton Bury canal, that Unwin made another grab for the younger boy. 'Look, Albert, the water', Unwin told him, grabbing him by the scruff of the neck and by his trousers.

Fearing something dreadful was about to happen, Horace turned on his heel to get help from the woman who had given him directions. Then, in the company of a number of soldiers, Horace returned to the bridge, but it was too dark to make out anything in the water and there was no sight of Unwin. He was then taken to a police constable who accompanied him home.

Unbeknown to her that Unwin had taken the boys into Bury, Eliza Osborne had been fraught with worry since they had failed to return home from school. She contacted the police and her fears where compounded when Horace returned home with the policeman later that night. Early on the following morning, Eliza went to the

Moonlight Tragedy.

RADCLIFFE MAN CHARGED WITH MURDER.

Life Story Revelations.

Newscutting relating to the Radcliffe Canal murder

school to see if there was any further news, and as she was returning home down Mount Sion Street she spotted Unwin. As she approached he turned on his heels and as she pursued him she called out 'Where is my lad?'

'Find him!' Unwin coldly called back as he hurried away.

Eliza Osborne then hurried to the local police station where she spoke to Police Constable Hodkinson. The officer then left the station and returned within thirty minutes in the company of Albert Unwin whom he had recognised and detained a short distance from the station.

In the presence of Mrs Osborne, Sergeant James Hulme questioned Unwin and told him he was the man Mrs Osborne claimed had taken her boys out of school.

'Where are the boys?' Hulme asked him.

'Horace ran away' he replied, and when asked where Albert was, Unwin replied coldly, 'He is in the canal. I cannot tell you where but I can show you.'

Unwin then made a statement and when the body of Albert Osborne was recovered in the murky canal Unwin was charged with murder.

On Saturday 19 February, Unwin appeared at the Manchester Winter Assizes before Mr Justice Bailhache charged with the wilful murder of Albert Unwin. He pleaded not guilty. From the outset it was clear that Unwin's defence would be insanity, and the court heard that Unwin had made attempts to commit suicide in the past and while working in a mine in his youth he had, for no reason, killed three pit ponies. Both his former wife and an uncle were inmates in an asylum and fifteen years earlier the prisoner, whilst travelling on a train, had got onto the roof of the carriage with the intention of throwing himself off in an attempt to commit suicide.

In 1912, while serving a sentence at Wakefield Gaol he had suffered an epileptic fit and again in the following year he was charged with attempting to commit suicide while suffering from mental depression. Believing he was suffering from Melancholia, he was not certified insane and released into the care of his sister.

The defence also claimed that since his relationship with Mrs Osborne's husband had become public knowledge he was living in fear of his life, as he believed that Albert Osborne senior planned to kill him. There was no substance to these beliefs and under examination by medical officers whilst held at Strangeways Gaol, Manchester, Unwin's manner and statements he made convinced them he was insane.

To a prison guard Unwin had admitted a few days after the crime:

> Do you know I can still see the little beggar's face as he was struggling in the water. I could not bear to see him so I knelt down on the towing path and pulled him out with my walking stick and brought him round. He was very exhausted and could not walk so I picked him up and carried him about 150 yards, thinking of taking him home. I then thought of his mother seeing him so wet and shivering with cold so I decided to throw him in again. My brain must have been turned up!

The trial lasted just a few hours and when the defence called to the stand Dr Norwood East, medical officer at Manchester prison, his evidence of Unwin's insanity proved crucial and the jury needed just a short time to bring in a verdict of guilty but insane. Unwin, who had callously killed a young boy to get back at its mother, was then sentenced to prison until His Majesty's pleasure be known.

CHAPTER 4

A FATAL THREE MINUTES

It was while out drinking with friends in Salford on Tuesday 18 April 1916 that twenty-year-old Matilda 'Tilly' Davies met James Allen, a twenty-one-year-old ship's fireman. Described in the press as a stunningly pretty mulatto, Tilly lived with her parents, a black father and white mother, at 3 Bashall Street, in the Victory district of Bolton.

Allen, a native of Sierra Leone, was a strapping six-foot tall handsome man, who had joined the SS *Ravenstone* in January 1916, which was currently moored at number 9 Dock, Salford. There seemed to be some attraction between the two and as they parted Allen was invited to visit Tilly in Bolton on the forthcoming Good Friday.

In the company of two fellow sailors named Spooner and Gill, Allen arrived in Bolton on the Friday as arranged and made his way to her house where he met her father for the first time. Frederick Davies, a father of six who had worked for thirty-five years as an oiler and greaser in a local mill, seemed pleased enough to meet her daughter's new friends and invited them into his home.

Instead of travelling back to their ship the sailors were offered a bed for the night by a neighbour, Mrs Ellen Wilson, who lived across the road at number 4. The evening seemed to pass well and at the end of the night Matilda bade her friends goodnight and returned home.

It was on the following morning that events took place that ended in tragedy. Tilly called round to the house after breakfast, and for a short time she and James Allen were left alone. In what the inquest called a fatal three minutes, whatever passed between the two we will never know. From the other room friends heard gunshots and, hurrying into the front parlour, found both Tilly Davies and James Allen lying fatally wounded. Both were dead by the time police officers and a doctor were summoned to the house.

An inquest held on the following Monday, before Bolton Borough Coroner Mr J. Fearnley, heard that Allen had shot Tilly Davies with a six-chambered revolver before turning the gun on himself. Davies' shipmates who had been with him on the night out in Salford claimed he had built up an instant infatuation with the pretty young girl, so

BOLTON MURDER.

SENSATIONAL INQUEST STORY.

Revelations Respec* of Fatal Interview.

MEETINGS OF THE PARTIES.

Cutting relating to the murder of Tilly Davies

much so that following the invitation to her home he had spent his wages on new clothes before travelling to Bolton.

Her friends seemed to suggest that Tilly had not given out her address to Allen but one of her friends gave it one of his shipmates and he had invited himself over so he could pursue his quest for her. It can only be surmised what actually happened when the two were left alone. Perhaps he made some remark about his affection for her that she took offence to or perhaps she was worried he was moving too fast.

The short inquest ended with the finding of a verdict of wilful murder against Matilda Davies, carried out by James Allen who had then committed suicide by shooting himself.

CHAPTER 5

WHO KILLED OLD REUBEN?

To the folks of Little Lever, a small colliery village on the outskirts of Bolton, he was 'Old Reuben', a kindly bachelor and ex-councillor who kept the hardware and blacksmith's shop at 3 Market Street. At seventy-eight years old, Reuben Mort, despite his years, still made for an imposing figure, standing well over six-foot tall and having a stocky build. Although teased by the local children on occasion and thought a bit peculiar by some of his neighbours, he was generally thought to be without an enemy in the world.

On Sunday evening 18 January 1920, Reuben Mort was visited by his nephew James Stringfellow who ran his own drapery business on nearby High Street. They chatted for a while, and after sharing a drink James bid his uncle goodnight and returned home. Mort was a man of habit and at 3 a.m. he woke as usual and set about making himself a cup of tea whilst stoking up the fire in the forge so that it would be ready for business in the morning. At 4.20 a.m. neighbour Jack Lomax and his wife, who ran the local tripe shop, were woken by the sound of banging coming from next door. They dressed quickly, and when there was no answer to their knocking on the front door, they went to summon Mort's former housekeeper Mrs Davies who lived around the corner and had keys to the shop.

Returning to the shop they saw that the wooden board the old man had fixed over a window, damaged by a storm just before Christmas, had been pulled away. Lomax shouted inside and he heard the old man mumble something before sliding open the lock on the door. They recoiled back in horror at the sight that greeted them. The old man's face was streaming blood, and there was a trail across the oilcloth floor leading into the sitting room at the back. Mort told them that while he was stoking the furnace he looked round and saw an intruder wearing a mask. The man demanded the keys to the safe, which stood in the corner.

'I don't have them,' Mort told him. 'I don't believe you,' the masked man snarled, and when Mort re-affirmed that they weren't on the premises the intruder pulled out a cosh and approached. 'In that case I will kill you,' he declared, before raining a series of fierce blows on the old man.

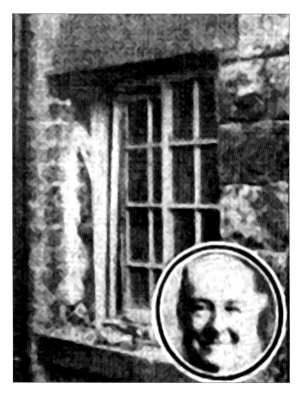

Picture of Reuben Mort and the window of his shop where his killer gained entry

Whilst Mrs Davies hurried to fetch Dr Nuttall who lived close by, Lomax comforted the old man while his wife summoned the police, who were soon at the scene. Before arranging for Mort to be taken to Bolton Royal Infirmary, officers questioned him about the attacker, but apart from saying he was tall and wore a mask he couldn't recognise him and didn't think he would if he saw him again.

Reuben Mort died from his injuries soon after being admitted into hospital, and a murder investigation began. From the state of the house it was clear that the attacker had made a search of the premises, presumably in trying to locate the keys. Drawers had been pulled out and the contents ransacked and strewn across the floor, but it seemed the killer had neglected to search a cupboard in the kitchen. There, hanging on a nail, was the bunch he had been searching for. Inside the safe was a vast amount of money: over £2,000 in notes.

Robbery was clearly the motive, and as locals were questioned it soon became clear that rumours the old man was rich were indeed true. Police discovered he owned several properties in the village as well as having a considerable amount of money, both in the safe and in a local bank.

The investigation soon ground to a halt. Although they received several tip offs, interviewed a number of suspects and swooped on properties, both in Little Lever

and across Bolton, there was nothing to link anyone to the murder. The best lead they could come up with was that a traveller from a fairground had been seen loitering in Little Lever town centre on the afternoon of the murder. Various people gave very vague descriptions of him, but several agreed he was a tall man.

Other than that there was nothing. Local police called in Scotland Yard for advice and relatives of the murdered man put up a substantial reward of £100 for information leading to the arrest of the killer. A local 'retired' burglar contacted the police and offered his assistance, claiming he had experience that may be useful to their investigation. After ruling him out of their enquiries, they politely refused the offer.

On 23 January, the funeral took place of Reuben Mort at St Matthew's church. The cortege left from the home of Mort's nephew James Stringfellow and there was what the local newspaper reported at the time as an 'exciting incident'. As the procession formed to head to the church, the horses pulling the first coach behind the hearse refused to budge. No amount of coaxing and persuading could get them to move and finally the mourners had to climb out of the carriage and follow behind the coffin on foot.

Word spread that it was because of local superstition that the horses had failed to move because the eyes of the murderer were on the procession. It was rumoured that an old gypsy woman living near the village had prophesised that this would happen!

A week after the funeral took place an inquest was held in Bolton. The coroner, Mr J. Fearnley, returned a verdict of 'murder by person or persons unknown'. He told the packed assembly that he could only deal with actual evidence brought before him and he did not propose to listen to the numerous rumours that had been sweeping the district. Pretty much every male over the age of sixteen who had been standing watching the funeral possession, had at some point been mentioned as the potential murderer.

'You will probably have heard all sorts of silly idiotic rumours — "such a person has done it" — even such cruel rumours that relatives have done it,' he said, stating that he was making this announcement as he believed it cruel of people to make suggestions of that description.

Investigations went on for the rest of the year and enquiries took officers to all parts of the county. Finally the hunt was scaled down and reluctantly the dossier was filed as unsolved. The dust on the file was periodically brushed off when some fresh lead emerged but, like others before it, it soon amounted to nothing.

Thus the killer of Reuben Mort was never brought to justice and the case remains open, as an unsolved murder case is never closed. Who was the killer? Who was the mysterious gypsy type seen in the area shortly before the murder? And was the killer one of those paying their respects as the cortege assembled before the funeral? Like the detectives investigating the murder ninety years ago, we will never know.

CHAPTER 6

THE ONE-LEGGED NIGHT WATCHMAN

'I will bet you a week's wages I will get her.'
Statement by William Thorpe to his landlady Gwendoline Griffiths,
Thursday 19 November 1925

Sitting in the taproom of the Hare and Hounds on Bury New Road, Bolton, William Thorpe cursed and drank, alone in his private grief, devastated that the woman he loved had married another man. Earlier in the summer of 1925, shortly before the annual wakes holidays, when Frances Godfrey found herself pregnant she asked Thorpe, the father of her baby, to marry her. He had refused and she had wasted no time in finding someone who would. William Clarke, who had known Frances for several years while she had been courting Thorpe, was prepared to marry the pregnant Frances and from then on she severed all contact with Thorpe.

Thorpe, a forty-five-year-old, one-legged ex-soldier, had lost the lower part of a leg during the Great War, and now wore a leather false limb with a wooden foot attached, earning him the nickname amongst his friends of 'Peg leg'. He had met Frances when they lodged together and for a time he had lived with her at her mother's house, and once he realised she was serious about marrying Clarke he set about trying to get her to change her mind. He now told her he would indeed marry her but she refused his repeated requests to change her mind, and when he heard she had married William Clark on 1 August he knew it was all too late.

Thorpe's demeanour changed almost overnight. He went from being hardworking, industrious, jovial and friendly into a miserable, reclusive drunk and took to moping around the building site at the new Crompton Fold estate, Breightmet, where he worked for William Gornall and sons as a labourer and watchman. His landlady at his home at 1 Crompton Fold and all his friends and workmates noticed the change in him but they seemingly didn't realise just how much it had upset him. Thorpe discussed his situation with landlady Gwendoline Griffiths, who told him he had best just let it pass, as there was nothing he could do about it now. Thorpe then made the grim bet of a week's wages he would win her back.

Letter informing the Governor at Strangeways that the execution of William Henry Thorpe would go ahead

On Thursday evening, 19 November, after collecting his weekly pay Thorpe headed straight for his local pub. He then caught the trolley bus into Bolton town centre where he further drowned his sorrows, before catching a bus back to the Hare and Hounds, 'Twisses' as it was known locally, to finish the night off.

As the landlord called last orders, Thorpe ordered a pint bottle of rum and, after handing over ten shillings for the drink, he made his way home to his lodgings. Throughout the night he drank and brooded, and before he fell into a drunken sleep he decided that if he couldn't have Frances then no one would. He woke before dawn

and began to dress. When asked by his roommate, landlady's son Cornelius Cain, where he was going, Thorpe simply said he was going to the toilet. The lavatory was in the garden some 40 yards away and Cain went back to sleep unaware that Thorpe had failed to return to his bed.

Thirty-nine-year-old Frances Clarke, nee Godfrey, shared a small terrace house with her new husband and her seventy-year-old mother at 9 Clarke Street, in the Victory district of Bolton. At 5 a.m. on the Friday morning, William Clarke left home and made his way to Little Lever where he was employed at Potter's Chemical Works. Leaving Frances asleep in the back bedroom, he locked the back door but left the gate on the latch.

Less than an hour later, Frances' mother was suddenly woken by a piercing scream coming from the adjacent room. As the old woman sat up in bed she heard a familiar thumping noise coming from her staircase — as though someone was making a quick exit. She rushed towards Frances' room and opening the door she recoiled in horror: her daughter lay on the bed with a terrible gash to her throat. As blood gushed from the gaping wound, Frances whispered a name to her mother; 'Thorpe'.

Assistance was quickly summoned; the Fire Station ambulance hurried from nearby Marsden Road, but by the time it had rattled down the cobbled street Frances Clarke was dead. Dr Dickie made his way to the house where police officers directed him to the body. He found that she had died as a result of a gaping wound to her throat, presumably caused by a razor. Thorpe had gained entrance into the house by breaking a window in the downstairs kitchen.

THORPE HANGED.

Last Scene in Bolton Tragedy.

MORBID WOMEN.

Crowd Waits Outside Strangeways Gaol.

William Thorpe, the Bolton watchman, who was found guilty at the Manchester Assizes, on February 24, of the murder of Mrs. Frances Clarke, with whom he had kept company before her marriage, was hanged this morning at Strangeways Gaol.

The executioner was Willis.

About fifty people, mainly women and young girls, assembled outside the gates of the gaol some time before the execution. The majority of them were evidently employed in the neighbourhood, and had left their homes earlier than usual in order to wait outside te prison during Thorpe's execution before proceeding to their work.

HEAVY MIST.

The scene was still enshrouded in the heavy morning mist when the bell tolled; and then there was the rush to read the notice that the execution had been duly carried out.

Thorpe, who was 45 years of age, received the sentence of death at the trial with unshaken calmness.

The evidence showed that Mrs. Clarke was found one morning lying on her bed with her throat terribly gashed.

Her mother, disturbed by her screams, heard the thump of Thorpe's artificial leg on the stairs.

POIGNANT LETTER.

In a poignant letter, written by Thorpe to Mrs. Clarke just previously, occurred such phrases as: "I shall never forget you, dear pal. . . I think we could have been so very happy together."

Thorpe, in the witness box, said on the night before the murder he had been drinking rum, and he remembered nothing more until he was groping his way home the following morning.

A petition praying for a reprieve was signed by over 7,000 people.

INQUEST PROCEEDINGS.
Execution Expeditiously Carried Out.

A report of Thorpe's execution appeared in newspapers across the county

Whilst a post mortem was being carried out by Dr George Mowat at School Hill Mortuary, detectives already had the wanted man in custody. Arrested in his lodgings, Thorpe told Detective Inspector James Clegg and Police Constable Walter Fisher, as he was placed under arrest, that he was planning to cut his own throat, having made a number of unsuccessful attempts to take his own life that morning.

Firstly he had tried to throw himself under the wheels of a tram as he escaped from the scene of the crime. Due to the weather the tram was only crawling so the

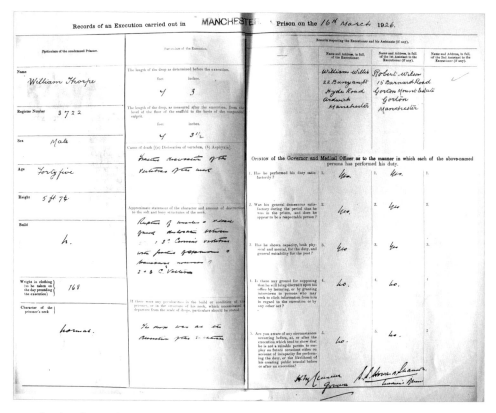

Details of William Thorpe's execution were recorded in an official LPC4 form along with the conduct of the executioners

driver was able to brake and avoid hitting him. He had then jumped from the cab and angrily remonstrated with Thorpe who responded by pushing him to the ground and disappearing into the thick fog that enveloped the town.

Thorpe then returned home, telling Cornelius Cain that he had been watching the morning gallops. He then left the house and made an attempt to drown himself in a nearby canal but being unable to hold his head under the water he had returned home, and had been about to draw the razor across his throat when the door burst open and he was placed under arrest.

Thorpe's trial opened before Mr Justice Wright at Manchester Assizes on 23 February 1926. The prosecution had built up a strong case against the accused with his defence claiming that drink had rendered Thorpe insane. In his summing up, which seemed to side with the defence, Mr Justice Wright said that in some cases people who were very drunk were insane. Addressing the jury he said that they all knew from sad experience that drunkenness did weaken a man's self-control and, as a result, he very often did things he would not do when sober, and in some cases a

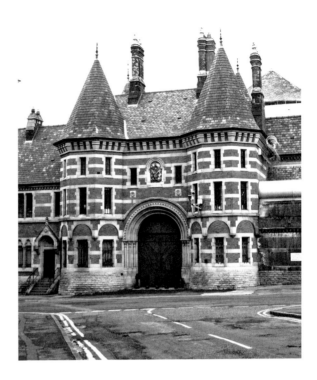

Strangeways Gaol Manchester

man may be so drunk as not to be able to form the necessary intention to commit a crime. But was this insanity?

The jury needed just thirty minutes to find the prisoner guilty of murder but added a strong recommendation for mercy. Thorpe stood unmoved as the death sentence was passed. He decided not to appeal against conviction although numerous petitions were organised in an attempt to secure a reprieve. One petition in Blackpool, Thorpe's birth place, collected over 7,000 names and similar numbers were collected by friends at his former work-place and in many Bolton town centre pubs, but four days before the date scheduled for his execution the Home Secretary announced that Thorpe must die.

Thorpe penned many letters from his cell in Strangeways Gaol. He refused a request by his solicitor Adam F. Greenhalgh to see him on the evening before his execution, as he penned one last letter to a friend in Bolton, who had been a regular visitor throughout Thorpe's time in prison. In it he thanked him for all his efforts in trying to secure a reprieve on his behalf, asking him to pass on his thanks to all his friends in Breightmet. He ended the note poignantly saying 'goodbye for ever and ever, your old pal, William Henry Thorpe.'

Frances Clarke was avenged on a foggy Tuesday morning, 16 March 1926, when Thorpe walked bravely to the gallows where he was hanged by William Willis and his assistant Robert Wilson.

CHAPTER 7

INSIDE THE LOCKED HOUSE

When he stood before the Borough Prosecutor at the courthouse on Mawdsley Street, Bolton, the first clear signs that the prisoner was insane were already revealed to the packed court. It was the second murder reported in Bolton within the last fortnight, following William Thorpe's recent arrest and there was a great deal of excitement in the town. Albert Manning, a thirty-seven-year-old unemployed boilermaker, took the stand, and when asked how he pleaded to the charge of murdering his wife, he simply replied, 'I don't know whether I am guilty or not'!

It was on Monday evening, 30 November 1925 that the body of forty-seven-year-old Elizabeth Manning was discovered inside her locked home at 34 Chalfont Street. She had been strangled.

Police had issued a wanted notice for Manning who was described as being thirty-seven years old, 5 feet 5 inches tall, with a pale complexion, blue eyes and dark brown hair. His head was described as being much broader on top than was usual. Manning was said to have a slender build and he had a tendency to lean forward when walking. Until recently, he had been employed at Booths Steelworks off Hulton Lane.

Manning had come to the attention of detectives in Bolton two weeks before, when on Saturday 14 November, he had walked into Bolton Police Office and said that he wished to give himself up for strangling a woman at Nottingham on the night of 5 November. Reported as being quiet looking and depressed, Manning was detained in custody. He was then handed over to detectives from Nottingham who, charging him with wilful murder, took him back to the city to carry out their own enquiries. The murder enquiry in the East Midlands soon led to nothing and after being held for ten days Manning was released.

Relations between Manning and his wife of ten years had not been well for a while and his behaviour in recent weeks, culminating in the confession to a murder he had not committed, caused her to seek legal advice regarding a separation. While Manning was in Nottingham, Elizabeth had moved out of their home on Chalfont Street and gone to stay with her sister and brother-in-law at their home on Sweetloves Lane.

Enquiries into the murder of Mrs Manning found that on the day of her death, she had returned to check up on the Chalfont Street house. At 9.30 a.m. that morning she spoke to Esther Caraher, a friend who lived close by, to whom she discussed her relationship with her husband. She said that they had been talking about moving home across town to the St Helen's Road area so as be closer to Booth's Steelworks where Manning would be able to come home for his dinner. These plans had been put on hold when Manning lost his job and then told her that he was 'clearing out' and going 'on tramp' in search of work.

Reaching her home, Elizabeth found the door locked and surmising her husband was inside she knocked on the door. It was eventually opened by Manning, who came down the stairs half-dressed, and letting herself in Elizabeth turned to Esther and said she was 'alright' and would see her later.

Esther called again in the early afternoon and Elizabeth, holding a duster in her hand, told her she was cleaning the windows and tidying up before going back to spend the night at her sister's house. Another friend and neighbour, Gertrude Bentley, called that afternoon and Elizabeth told her she would pop in for a cup of tea when she had finished her chores. When Gertrude was speaking to Elizabeth at the front door she could hear Albert Manning playing 'Abide with me' on the organ inside the front room. A short time later she heard the sound of glass breaking and going into the back yard she saw a window broken in the Manning's bedroom, and Albert Manning, wearing a brown army cardigan was covering it with cardboard and a piece of brown paper. She later saw Elizabeth sweeping up the glass in the back yard.

When Elizabeth failed to pop around as agreed by early evening, Gertrude called round but found the Manning's house locked and in darkness. A short time later Elizabeth's sister and brother-in-law and another of her sisters, concerned that she had failed to return to their home as planned, called at the house and also found it locked. They spoke to the neighbour who voiced her concerns, and it was decided to contact the police.

A plain-clothes officer, Police Constable Leonard Pallant, arrived and gained entry into the house by climbing onto the coal shed and forcing entry through the broken back bedroom window. Elizabeth Manning was lying on the bed still clutching the duster in her hand. Her purse lay opened on the bed, empty except for a penny caught in the fold. Detectives from the CID department were called and Dr George Mowat also attended the scene. He rightly suspected she had been manually strangled some hours before and this was later borne out at the post-mortem.

The hunt for Albert Manning ended late on the following evening when he walked into the Central Police Office at 10.58 p.m. Pushing open the swing door, he marched across the hallway, and as the officers at the front desk were engaged in some other business, Manning lifted the hatch on the front desk, entered the office and plonked himself down in an armchair beside the fire. At that moment Chief Inspector Orrell

and Detective Superintendent Hall who had been leading the hunt for the murderer entered the office. Seeing the man sat in the chair they demanded to know who he was and what he wanted. He stood up and simply said, 'Manning'. Having now shaved off his moustache since he had been questioned over his confession to the Nottingham murder, neither detective recognised him at first, as he now looked haggard and depressed. He was taken into custody and placed in a cell whereupon he slumped onto his bunk with exhaustion and fell asleep.

Such was Manning's conduct following his confession to the murder of his wife that his sanity was immediately questioned. His remarks at the inquest and subsequent remand hearings, in which he claimed he didn't know if he had killed his wife or not, supported this theory.

At his trial before Mr Justice Wright at Manchester Assizes on Thursday 25 February, his counsel claimed that Manning had no recollection of anything

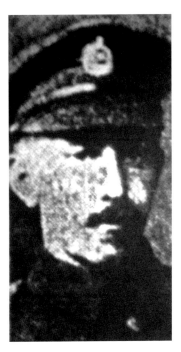

Albert Manning

following his confession to the murder of a woman at Nottingham in early November. He could only vaguely remember being released from custody in Nottingham and seemed to remember catching a train to Derby then onto Manchester. He said he could recall nothing else until he found himself in custody in Bolton.

Manning's brother Frederick was called by the prosecution to give evidence that, early in November, the prisoner had stopped at his house on Clarence Street one night, and while they were chatting said that he intended to strangle Lizzie. This, they claimed, showed that the crime was premeditated.

Medical evidence suggested that Manning had been unaware of his actions for some time, as was shown by the false confession to a murder that had never taken place, and the jury believing the defence's version of events, that the prisoner was not of sound mind when he strangled his wife, took just a short time to find Manning guilty but insane. Albert Manning was sentenced to be detained until His Majesty's pleasure be known.

CHAPTER 8

SUICIDE OR MURDER?

To Mr Justice Charles, presiding over his first murder trial since promotion to High Court judge, it must have seemed a straightforward case in which to make your assize court debut. After all, at the inquest held three weeks earlier at Bolton Borough Police Court, the prisoner, fifty-three-year-old William Holland, had already made a full confession, telling the court, 'I murdered my wife... I turned round and slashed her across the throat with a razor'!

Holland, described as a cotton waste sorter, had been accused of the murder of his forty-seven-year-old wife Mary, who had been found dead on the kitchen floor at her home at 13 Haydn Street, Halliwell, by her son shortly before midnight on the evening of Saturday 10 March 1928.

Several years before, Mary Holland had been badly injured in an accident, which had resulted in a broken ankle that had set badly and left her crippled and having to walk with a stick. As a result she had changed from an industrious hard-working woman to a bad tempered, foul-mouthed drunk.

On the night of her death, neighbours heard a quarrel at the house between Holland and his wife, during which very bad language was heard. The row, it seemed, stemmed from when their son, William junior, gave his father a pound note. Neighbours heard Mrs Holland say that if he husband did not hand over the money to her she would cut her own throat.

At 8 p.m. Mary Holland left the house and went to a neighbour's house where she asked a young lad, Ralph Charlson, to run an errand. She then returned home, and when Ralph returned from the errand the Hollands were still quarrelling.

At 11.30 p.m. William Holland junior returned home to be met by his father who informed him his mother was dead. William entered and found his mother lying on the hearthrug under the table with one side of her face lying against the floor with a terrible gash, which was five inches long, in her neck. A blood soaked razor lay on the floor close to the body. His father, pale faced and seemingly in shock, said to his son: 'I've done it.'

'You haven't. You don't know what you are talking about,' the son replied, who then picked up the razor, wiped the blood from it and replaced it in the cupboard.

The two men then agreed that a doctor should be summoned and together they walked to the nearby fire station where the ambulance was kept. Addressing the officials at the station, William junior made what was later termed in court as a significant remark: 'My mother has committed suicide at 13, Haydn Street.'

Holland senior made no comment at the fire station, but later, when questioned by Police Constable Walmsley, he made a detailed statement:

> I am a warehouseman employed by Joshua Barber and Co., of Shifnall Street. About 9.30 p.m. I went for a walk, leaving my wife, Mary Holland, aged forty-seven, in the house alone. On my return, about 11.30 p.m., I found her lying on the floor near the fireplace in the front kitchen, with her throat cut and a razor lying on the floor by her side. I spoke to her but she did not answer. I then went to the front door and there met my son William, who was just returning home, and we went to Halliwell Road together to look for a policeman, but were unable to find one.

Holland then told the officer that his mother 'had not been well for a long time, and had been under the care of Dr Calder for the last twelve months. He had been treating her for pains in the head and a bad leg.'

It was at the inquest, held a few days later, that there was a sensational development. After Police Constable Walmsley had given his evidence Holland was preparing to address the court when he made a dramatic claim.

'I have been keeping something back,' he shouted after taking the oath. He then threw off his coat and shouted that he had killed his wife.

> You want the truth and you shall have it. I murdered my wife; I was shaving at the time. She was goading me and calling me all sorts of rotten names. I turned round and slashed her across the throat and pushed her under the table. I went out and got three bottles of beer from the off-licence. The evidence I gave to the detective was all lies!

Following this dramatic revelation Holland was remanded in custody at Manchester's Strangeways Gaol, and was to make a further six appearances at the police court. At Bolton Borough Magistrates a total of twenty-one prosecution witnesses were called to give evidence, with proceedings delayed due to the illness of Dr J. E. Sykes of Bolton Royal Infirmary, who was giving evidence on behalf of the public prosecutors. Eventually, on Monday 16 April, Holland was arraigned on a capital charge to stand trial at Manchester Assizes in May.

When William Holland appeared before Mr Justice Charles on Monday 7 May, it was one of only two murder trials at that sitting of the assizes, an unusually light capital caseload for the city. Holland pleaded not guilty to the charge and was defended by Mr A. E. Jalland, KC, instructed by Mr Adam F. Greenhalgh of Bolton,

MURDER OR SUICIDE?

BOLTON HUSBAND'S TRIAL ON CAPITAL CHARGE.

PROSECUTION'S TRIBUTE TO "DECENT, STEADY MAN."

The proceedings in the Crown Court at Manchester Assizes to-day, presided over by Mr. Justice Charles, were of particular interest to Bolton.

In the dock was William Holland (53), cotton waste sorter, 13, Hayden-st., Halliwell, arraigned on the capital charge. He is also charged with attempted suicide.

It was the first *t.*_ of the only two man. He was keeping something back. trials in which murder was alleged that He had murdered his wife, and then when was to be staged at the present Assizes, the oath was read out he threw off his and it was also the third of its kind com- coat and said, " You want the truth and mitted from Bolton within a period of a you shall have it. I murdered my wife; I little over two years. was shaving at the time. She was goad-ing me and calling me all sorts of rotten

Cutting relating to the murder of Mrs Holland

while the Recorder of Bolton, Mr J. C Jackson, KC, and Mr A. T. Crossthwaite appeared for the prosecution.

Holland was described as being much brighter than at any time since his arrest and had taken a keen interest in the swearing in of the jury, which included two women.

Opening for the crown, Jackson told the packed courtroom that there were 'very peculiar facts' to be heard in the evidence. Holland, who was seated in the dock, was described as being a steady, hard working and decent man, who, although not altogether teetotal, was well thought of by his friends and neighbours. Jackson recited the evidence that had been presented at the magistrates' court and how Holland had not been a suspect until his own words had led him to be on trial for his life.

Jackson explained that blood had been found on Holland's clothing and boots and following a proper scrutiny of the body of the victim had revealed cuts on her hands consistent with her having attempted to save herself from a razor attack. He

conceded — following questioning from the defence — that the wounds were quite superficial, but on her right arm was a bruise consistent with someone having seized her by the arm.

'No matter how low a person, or how bad they may be,' Jackson continued, 'their lives are sacred in this country, and no one has the right to take that life. On the other hand, it may be a deadly weapon as against the defence because it may prove and show the motive there was for cutting her throat, viz., that she was a nagging woman, and had annoyed and goaded him on to a rash act which ended in her death.'

The son, William Holland, gave evidence and under cross examination by Mr Jalland said that whenever there was a quarrel the attitude of his father was that he would give her anything and would not let anyone say anything against her. 'Throughout her illness he treated her with kindness' Holland said.

Under questioning by his defence counsel, Holland junior said that he remembered on one occasion his mother had thrown a knife at his father, and on many occasions he had taken the kitchen poker upstairs and had hidden it from his mother.

Police Constable Walmsley, the officer who had been first to the scene, said he had treated the investigation purely as one of suicide, and Dr Sykes house surgeon at Bolton Infirmary told the court he could not say for sure whether the blood stains found on the accused's clothing had been there for a week, a month or even longer. He said that the wounds found on the victim were consistent with suicide but could have been inflicted by someone else.

As the proceedings were brought to a close, Holland's counsel addressed the jury and said that there was no evidence against the prisoner, other than the statement he had made at the inquest, and which he had now retracted. The jury seemingly agreed, and following the judge's summing up they took just a short time to return a verdict of not guilty and Holland was discharged. Secondary charges against him in relation to the self-inflicted wound, in relation to a charge of attempted suicide, were not proceeded with and he walked from the court a free man.

CHAPTER 9

THE BRIDE-TO-BE

What possessed a seemingly happy bride-groom to be to suddenly crack and commit a brutal murder, before turning the gun on himself was a mystery a coroner's jury were faced with in the spring of 1930. A tragedy took place in Bolton that horrified friends and neighbours of the couple and left a community reeling in shock.

They had been due to marry in June 1930 and friends thought them ideally suited. The groom-to-be, Charles Greenwood, a forty-eight-year-old bachelor of 344 Deane Church Lane, worked as a police sergeant and his betrothed, Mrs Annie Emma Brabbin, a forty-eight-year-old widow, lived with her son at 10 Mellor Grove, off Chorley New Road, in a house Greenwood had bought for them to move into following their impending marriage.

The peace of a spring morning was shattered shortly before noon on Tuesday 6 May, when Greenwood turned up at Park Hill Bowling Club on Russell Street. According to steward Mr Middlehurst, Emma Brabbin turned up at the clubhouse shortly after 9 a.m. that morning to help prepare snacks and drinks for members and players at the bowling club. At just after 11.30 a.m. Greenwood called on Middlehurst, whose house was adjacent to the clubhouse and asked to see Mrs Brabbin. He was invited inside the house but refused and asked if Middlehurst would send his young daughter Molly across to the club with the message for Mrs Brabbin.

Molly agreed to fetch Mrs Brabbin and moments later she emerged from the clubhouse, walking behind the young girl. She approached Greenwood who had moved away from the house and now stood beside a street lamp opposite the entrance to the club. In an instant he pulled a Webley revolver from his hip pocket and fired a shot. Middlehurst watched in horror as Mrs Brabbin cried out 'Oh!' as the bullet struck her. She turned and tried to make her way back into the clubhouse but slumped to the ground in the entrance where Greenwood stepped in closer and fired three more shots at her stricken body. He then walked back up the path and seeing Middlehurst standing watching, Greenwood turned the gun and shot himself through the heart. As Sergeant Greenwood fell dead to the ground, Middlehurst hurried to summon the police.

At the inquest held later that week it was recorded that Greenwood had been appointed as a police constable in 1908 and had served in the Royal Garrison Artillery between 1915-1919. Following his demob he returned to the police and was promoted to sergeant later that year. He was a popular officer and his actions had shocked and surprised all his fellow colleagues. He was just two months off his forty-ninth birthday and fourteen months away from completing his service with the police. Those who knew him well said he was looking forward to his impending marriage and his forthcoming retirement.

Annie Brabbin, who left a grown up son, had been widowed two years before. Her sister said that Annie had been keen to marry Greenwood but there had been some resentment in her family about the wedding. Perhaps something had been said that caused her to change her mind about the forthcoming nuptials.

There had been nothing to suggest Greenwood was suffering from any form of insanity and one of his colleagues said he was such a fine fellow and the last person on earth to do such a thing.

It was never established why he had chosen to shoot his bride-to-be then turn the gun on himself. The inquest ended with the jury finding that Annie Brabbin had been murdered by Charles Greenwood, who had then taken his own life.

CHAPTER 10

MURDER ON THE EAST LANCS ROAD

In their respective condemned cells at Manchester's Strangeways Gaol, the prisoners were counting down their last hours. After an assizes trial, conviction, then failed appeals and petitions, it seemed nothing beyond a last minute reprieve would prevent the hangman from performing his grim duties on the following morning.

In one cell, Max Haslam, a twenty-three-year-old crippled dwarf, had all but given up hope. His brutal crime — he had battered to death a wealthy recluse at Nelson, and then strung up her pet dog, before stealing the woman's jewellery — had caused outrage not just in his local community, but also across the whole of the North West, and despite his infirmity he had gained little in the way of sympathy. Even his own father had said that if the hangman didn't string him up he would do it himself.

Across the corridor, in the other condemned cell, George Royle, a twenty-six-year-old electrician and petty criminal from Stockport, was a little more buoyed up. During the last week a black cat had strayed into the prison grounds and formed an attachment with Royle, and believing that it was sign of good luck, he had gradually come out of the depression he had slumped into since conviction.

His crime, while not as horrific as Haslam's, had still made the headlines across the whole country, and resulted in large crowds clambering to view proceedings when the prisoner appeared in court where details of the crime were revealed.

Shortly after 10 a.m. on the morning of Thursday 8 October 1936 railway signalman James Rigby Lowe was out walking his dog prior to starting his shift with the L.M.S. railway. As he neared the Greyhound Inn on the East Lancs Road, Leigh, near an area known as Bent's Pit, the dog became attracted to something lying close to a fence, beyond a low hedge, some forty feet away from the road. When it began to bark Lowe went to investigate and found himself looking down upon the body of a woman covered over with a blue raincoat.

Rowe hurried out into the road and flagged down a lorry driven by William Nattrass of Moss Side. Nattrass accompanied him to where the body lay and confirmed what Rowe had seen. He then went to find a policeman and Police Constable Douglas Sanderson of Lancashire Constabulary, based at Leigh, was the first to the scene.

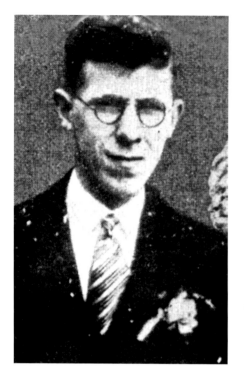

East Lancs Road murderer George Royle

Viewing the body he saw that she clearly dead and found that the victim's face was discoloured and swollen, and blood had oozed from her nose and mouth. A search of the area discovered a handbag and beret lying close by and the officer also found marks on the ground, which suggested that she had been dragged through the hedge to where she had been discovered.

Acting Detective Inspector George Duck and Detective Sergeant George Buttfield, both of Lancashire Constabulary CID, based at Preston, were soon on the scene, and a post mortem carried out by Dr Arnold Renshaw found that cause of death was asphyxiation — from the blue and white scarf removed from around her neck. Besides marks from the scarf, which had been tied in a reef knot, there were also deep impressions of a beaded necklace the victim was wearing

Renshaw told detectives that it looked like foul play as in his opinion cause of death could not have been self-inflicted. He also stated that she had been dead at least twenty-four hours and suggested that the body had been dragged by the legs through the hedge to where it was discovered. Renshaw also told officers that besides the marks from the scarf on her neck, there were other marks, which suggested manual strangulation. He also found that the woman had a goitre, an enlarged thyroid gland, which meant she may have needed less pressure on her neck than normal to cause her death.

A murder enquiry was then set up and the identity of the woman was soon ascertained. She was found to be a thirty-four-year-old Manchester prostitute, who worked under the name of Ethel Jones, but whose real name was Mary Josephine Holden, of 10 Severn Street, Manchester. Witnesses soon came forward with a host of clues. Mary had last been seen when she left her lodging on the previous Tuesday evening. She had been seen drinking in the Britannia Protection public house on Great Bridgewater Street, in the city centre, leaving in the company of a man named Hobson. Hobson said he had accompanied her to Victoria Station where she had purchased two tickets to Oldham. He said they had parted at about 10.30 p.m.

A few hours later, a man named Beard was walking along Eccles Old Road when his attention was drawn to a green saloon car being driven very fast away from

Manchester in the direction of Eccles. The door was half opened and a woman was hanging out shouting and screaming, 'Stop, stop, let me get out!'

The witness was able to tell the officer that the vehicle registration was COE 136, and a check on this found that the car had been reported stolen on the Tuesday evening. At 12.30 p.m. on Friday, Royle was arrested in Peterborough when Inspector Frost spotted a car with the registration number COE 136, as it was being driven through the town. He asked the driver to get out of the car and the man immediately told the inspector, 'It has got to come, I want to get it over.' Frost, who was only concerned with the issue of the vehicle and was not aware of the murder enquiry, asked what the trouble was, and, holding his head in his hands, Royle said he had stolen the car in Stockport.

Taken into custody, a search of the car found a railway ticket issued at Manchester Victoria on 6 October, and a number of sulphur tablets, identical to ones found in the handbag of the murdered woman. Held on a charge of driving a stolen car, Royle was detained in custody while officers made their way down from Stockport to continue their enquiries.

Led by Detective Inspector Williams they examined the vehicle and questioned the prisoner. Asked about the ticket found on the back seat, Royle said that it must have belonged to a man from Hyde he had given a lift to. Placed under arrest, he was returned to the northwest where he was charged with the murder of Mary Holden and the theft of a motorcar valued at £200.

'I had no intention of harming her, only to keep her quiet', Royle eventually admitted when he appeared at Leigh Police Court on 11 November. Evidence was then given about the discovery of the body and the arrest of the prisoner in Peterborough and ended when Royle was committed for trial.

When Royle appeared before Mr Justice Lawrence at Manchester Assizes on Monday 7 December, there was a considerable crowd in the public galleries at the court. The prosecution was led by Mr N. B. Goldie, KC, assisted by Mr P. R. Barry, while Mr E. G. Hemmerde, KC, and Mr C. T. B. Leigh handled Royle's defence. The jury consisted of two women along with the ten men.

The court heard that prior to the discovery of the body Royle had spent the last few weeks travelling the country, usually hitch hiking lifts from lorry drivers, as he moved from town to town, and had left Birmingham on the Monday afternoon heading for Manchester. He booked into a temperance hotel under the name of R. Smith and then travelled to Stockport where he had stolen the car belonging to a commercial traveller named Bloor.

Royle said that at about 9 p.m. on the Tuesday night he had taken the car from outside the White Lion Hotel, Stockport and was driving through Manchester when he stopped alongside a man and a woman, near Victoria Station. Royle asked the man if he knew where Grosvenor Street was as he had booked a room at the Pearson

Hotel. The woman said she knew where it was and she was going that way. Offering her a lift, she climbed in beside him and directed him towards the hotel.

No sooner had they started driving than the woman demanded 10s for her room, and if he gave her another 10s he could spend the night and have sex with her. Royle said he had refused, and anyway he only had 16s in his pocket. She then began to shout at him and in an attempt to quieten her down he gave her a 10s note, telling her he would take her wherever she wanted to go. She said she wanted to go to Liverpool, but, perhaps fearful of being picked up driving the stolen car, he said he would drop her off on Liverpool Road.

As he accelerated down the road she began to hurl insults at him, opening the door and continuing to insult him and telling him to stop the car. Royle began to panic and turned into a side street where he tried to quieten her down. He also demanded she give him his money back. She refused and began to scream, causing him to grab her by the scarf she wore around her neck. She then fell silent and, leaving her slumped unconscious in her seat, Royle set off down the East Lancs Road. As he approached Leigh he noticed that she had not stirred. He pulled to the side of the road and in panic dragged her out of the car, up the incline and behind the privets and then, he told the court, to prevent her from catching cold, he had covered her with her coat.

Royle maintained he had not intended to commit murder and he had left the scene believing she had just fainted. He said he had only learned of her death when he was informed by a police officer on the train back from Peterborough to Manchester prison. His defence counsel ended their evidence by asking for a verdict of guilty of manslaughter, stating there was no evidence of strangulation and as medical evidence had found she had the goitre this backed up their claims it was an accident. They also suggested that if Royle had had anything to hide beyond stealing the car, he would have removed the incriminating evidence of the sulphur tablets and train tickets.

Despite denying he had committed murder, the crux of the case — that she had died as a result of his actions — were not in dispute, and summing up Mr Justice Lawrence told the jury there were several points to consider:

> The first question you have to make your minds up about is whether you believe the prisoner's evidence, or believe his statement... Have you any reasonable doubt that he tied the scarf? If you have any reasonable doubt then you will find him not guilty of murder...

Once they had considered their verdict the jury returned to find the prisoner guilty of wilful murder, and as Royle was asked if he had anything to say before sentence of death was passed, his mother began to scream in the public gallery. Once Royle

HOME OFFICE,

WHITEHALL.

696,898.

3rd February, 1937.

Sir,

I am directed by the Secretary of State to inform you that he has had under his consideration the case of George Royle, now in the Prison at Manchester under sentence of death, and that he has advised His Majesty to respite the capital sentence with a view to its commutation to penal servitude for life.

I am,

Sir,

Your obedient Servant,

R. R. Scutt

The Secretary,

Prison Commission.

Letter confirming George Royle had been reprieved

had been removed from court his mother asked the judge for permission to speak to her son and, seeing her, Royle rushed towards her in tears begging, 'Mother, mother help me!'

Following conviction the jury then heard that Royle had a long criminal record and had attacked a woman just a few weeks before he had committed the murder. A date of Tuesday 29 December was fixed for execution and Thomas Pierrepoint was engaged as the hangman, with his nephew Albert recruited as his assistant.

At his appeal the judges agreed that the case was perfectly clear, and although the defence suggested the prisoner might be insane, a medical enquiry held while Royle was in Strangeways found that, although the prisoner may be exceptionally quick tempered, given to intermittent bursts of hasty and uncontrolled action, there was no medical reason for ordering a reprieve.

The Home Secretary reviewing the case noted that it was 'far away from a case of cold-blooded murder' and, believing that nobody should suffer the death penalty unless the object of his or her crime was the intention to take a life, he used his power to order a reprieve.

Royle heard news of his reprieve hours before the hangmen arrived at the prison and was so shocked at the news he asked the governor to repeat what he had just said. Visited by his mother that afternoon, he referred to the prisoner Haslam whose appeal had failed and to whom no mercy had been shown, telling her to 'Pray for him mother. God knows I pity him. Tonight I shall pray for him like I have never prayed in my life.' Haslam went to the gallows whilst Royle was removed from the death cell to the hospital before being moved into the main prison wing. He served the majority of his sentence at HMP Wakefield until he was released on licence on 21 November 1945, having served just less than nine years.

Royle was to soon return to a life of crime and was gaoled several times for shop breaking and larceny. In June 1956, he was sentenced to ten years after being arrested for larceny and following his arrest he told his arresting officer that he had strong sexual impulses, which he could not curb, adding, 'I am afraid if I am allowed out I will strangle some woman again'!

In the early 1960s, Royle was released again from prison, and following marriage in December 1963, he and his wife settled into a house at Heaton Mersey, Stockport. In the following year he found a job as a handyman at Butlin's Holiday Camp at Pwllheli, presumably keeping his past a secret from his new employers.

CHAPTER 11

'IN THE CANAL DOWN DARCY LEVER'

It had been in the summer of 1937 that long time friends and acquaintances Arthur Wyatt and Alice Aldred began walking out together. Thirty-two-year-old Wyatt, a year older than Alice, lived at 88 Viking Street, off Manchester Road, and eked out a meagre living scavenging at the tip behind Darcy Lever Labour Club for scrap metal and glass bottles and jars, which he would sell on to local dealers. Alice Aldred lived with her parents at 3 Alicia Street, Darcy Lever, and worked as a ring spinner at Tootal mills on Daubhill.

It wasn't long into their courtship that they began to have rows, usually after one or the other had been drinking, and these usually began when he became jealous over something she may have said or how he perceived she had behaved whilst they were out drinking. On one occasion shortly before Christmas they were together at the house of her brother, Sam Aldred, at Cinder Hill when another quarrel broke out between them. Suddenly Wyatt sprang up and threw a cup of hot tea into Alice's face shouting that he would 'do her in' if he thought anyone was going to have her.

As if that wasn't enough of a warning, they were together at her home on Christmas Day when following another quarrel he tried to choke her and when her father intervened he assaulted him to.

Despite this, the couple continued courting, and on Sunday 6 February 1938, they spent the evening drinking in Darcy Lever. Between 8 p.m. and 10.20 p.m. they embarked on a pub-crawl starting at The Farmer's Arms, where they each had a drink before moving on to the Volunteer Inn. Here they both sang songs as they drank, and when Alice, who witnesses claimed 'had been on the beer all day', had finished a version of 'Rose of Tralee' they finished their drinks and headed towards the Good Samaritan Inn.

At closing time they made their way back up Radcliffe Road towards her home on Alicia Street. At 10.30 p.m., church caretaker Thomas Nuttall was at the rear of his house at 290 Radcliffe Road, when he heard a woman shouting in a passageway close by. Nuttall heard the woman say, 'You know I love you!' and he then noticed Wyatt, who appeared, in Nuttall's words, 'very excited', strike the woman a heavy blow with

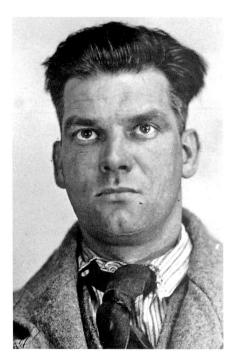

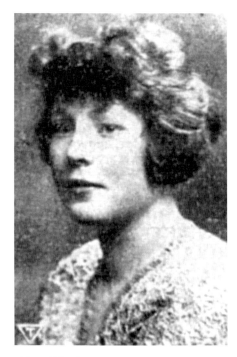

Arthur Wyatt

Alice Aldred

The rear of Radcliffe Road where Arthur Wyatt assaulted Alice Aldred

his fist. Nuttall went to assist and managed to get the woman away and let her into his house. Wyatt followed and a scuffle between the men took place in the backyard. Alice Aldred then made her escape from Wyatt through the front door.

Believing she had gone home, Wyatt hurried to Alicia Street only to be told by her father that she had not returned. Over the next hour he called twice more at the house, only to be told, as before, she was not there.

Around this time William Howarth was standing on Radcliffe Road close to the Labour Club near Agnes Street at a place locals called the 'Hole in the Wall.' Wyatt approached him and Howarth greeted him with a friendly 'hello' to which Wyatt responded by swearing and making threats towards him before walking away. A short time later Howarth saw Wyatt in the company of Alice Aldred walking back down Radcliffe Road.

At 11.45 p.m. Wyatt was alone again when he visited her brother's house at 29 Cinder Hill. Wyatt asked Sam if he could have a cup of tea and when asked where Alice said, 'Her's gone home.' He then rubbed his hands through his hair and began to cry, saying that he had been in a fight with a man from the chapel and been 'licked'.

No sooner had Wyatt walked away from Sam Aldred's house, Henry Hilliard, at number 25 heard a high-pitched squeal of a cat crying. He looked through the window and saw Wyatt bend down and pick something up and throw it across the street. Hilliard looked through the opened window and watched as Wyatt threw a coin into the air shouting that he 'might as well be skint now!' Hilliard then asked Wyatt for a cigarette who responded by throwing a twenty pack of cigarettes through the opened window. Ten minutes later Wyatt returned and knocked on Hilliard's door. Wyatt was told to go away as he was waking up the neighbourhood. Wyatt then reached into his pocket and threw some coins through the open window. Hilliard later discovered it was two half-crowns.

At 8.30 a.m. on the following morning, Wyatt was walking down Manchester Road when he passed the Rose Hill Hotel. Cleaner Elizabeth Howarth was polishing the front door, and she knew Wyatt well.

'Hello Arthur,' she said, 'What are you doing here?'

'I'm going to the Town Hall. You wont me see me any more', Wyatt replied. When she asked what he had done he told her calmly, 'You will see it in the headlines in the paper'!

Wyatt then made his way to the Central Police Station and spoke to Police Constable Stalman on duty in the enquiry office. 'I want to give myself up' Wyatt told the officer, and when asked what for he said, 'I pushed a woman in the canal down Darcy Lever, Alice Aldred, she's the one I've been knocking around with. I went in for her but...' Wyatt then hesitated, shrugged his shoulders and continued, 'Then I went home.'

Constable Stalman brought Wyatt into the CID office where he repeated what he had said to Detective Constable Frank Moss who noted down his confession. Up to

Joseph Openshaw shows where he found the body of Alice Aldred in the canal at Darcy Lever

this time no report had been received of any body being found in the canal at Darcy Lever, but moments later a call came through to the police station.

While Wyatt was speaking to detectives at the police station Nellie Hilliard discovered a dead cat on the pavement across from her house, close to where Wyatt had been on the previous night when she had heard a loud squealing. At roughly that same moment, Arnold Davies, a young butcher's errand-boy, was making his way to work along the canal bank when he noticed something floating in the water at a part of the canal called Dam Side Aqueduct, known locally as 'Wooden Bottoms'. On closer inspection he saw that it appeared to be a body, and seeing a worker further down the towpath he called for help. Joseph Openshaw, employed by the L.M.S Railway to look after the canal, hurried to assist and used a pole to fish the body out of the water and then called the police.

Alice Aldred's body was identified by her father and, with a man who confessed to putting her into the water, it seemed the police had a straightforward case to investigate. Her body was removed to Bolton Royal Infirmary where police surgeon Dr Mowat performed a post-mortem. He found that the victim had died as a result of asphyxiation through drowning. Alice Aldred had been just 4 feet 10 inches tall and weighed just 5 stone 3 pounds. Significantly, her heart was on the opposite side of the body to most people and her lungs weighed just 11 ounces whereas those of a healthy woman her age would weight over 30 ounces.

A further post-mortem carried out again by Dr Mowat in the presence of Manchester pathologist Dr Arnold Renshaw concurred that her death had been vastly accelerated

The canal after it had been drained

by her having the greater part of one lung missing. The body had some bruises about the face and upper body, which were likely to have been sustained before death.

Detectives called at Wyatt's house on Viking Street and found items of wet clothing hanging on the washing line, which suggested that Wyatt had been in the canal at some point prior to his arrest.

Detectives visited the canal bank and found that the depth of water where the body was recovered was just 4 feet 6 inches deep, shallow enough for most adults to have been able to touch the bottom, even someone who could not swim, as police had been informed was the case with Alice Aldred.

On Wednesday 23 March 1938, Arthur Wyatt appeared before Mr Justice Tucker at Manchester Assizes. Opening for the prosecution, Mr Noel Goldie, KC, told the jury there were three possible verdicts open to them: murder, manslaughter or not guilty. He then outlined the facts of the case, which began with the finding of the body, through the police investigations into her last hours and the confession of the accused, who had surrendered to police shortly before the body was discovered. He claimed that Wyatt had admitted to having pushed Alice into the water, following a quarrel in which he had accused her of being too friendly with a man they had spoken to in the pub earlier, and the fact he was seen shortly afterwards by both

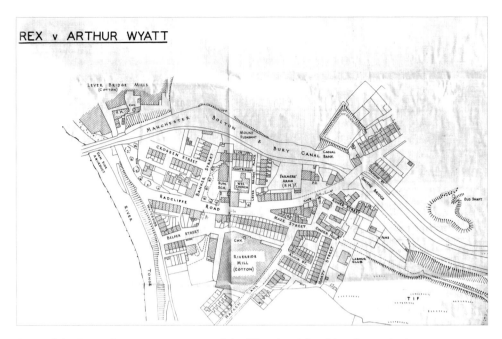

Map of the Darcy Lever area as prepared for Wyatt's trial at Manchester Assizes

Alice's brother and Henry Hilliard who both testified that his clothes were dry at the time. This suggested that after pushing her into the canal he had made no attempt to jump in to rescue her.

Wyatt's counsel, Mr Pritchard, told the court that the defence was that Alice's death was accidental and at worse the verdict should be manslaughter. He also suggested that the prisoner was insane and that his behaviour on the night of the crime, including the unprovoked killing of a cat shortly after he had deliberately pushed the woman into the canal, suggested he was acting 'in a frenzy'.

On the following day, the judge commenced his summing up telling the jury that if a man did something, the natural result of which was death, then he was guilty of murder, whether or not it was premeditated or whether he did it on the spur of the moment. He said that it had been made clear that Wyatt had not gone out that night with the intention of murder but through the consequence of his actions Alice Aldred had died. With regards to a verdict of manslaughter, this was a proper verdict if death was not the natural consequence of his actions that night. The judge referred to a comment the defence had made as they stated their case in which there had been 'horseplay' on the canal bank before the woman entered the water. 'If there had been any such horseplay there is one man who could — if there had been — have told you about it. He did not do so,' Mr Justice Tucker said as he concluded his summing up, which had lasted one hour and twenty minutes.

The jury were then asked to consider their verdict, and taking the same length of time the judge had to sum up the trial, they returned at 1.50 p.m. to find Wyatt guilty of murder but with a strong recommendation for mercy.

Asked if he had anything to say before sentence was passed, Wyatt said, 'No, Sir' and smiled as sentence was passed on him. He then walked firmly from the dock to the cells below.

Tuesday 12 April at 9 a.m. was fixed for his execution and letters sent to chief executioner Thomas Pierrepoint and his nephew Albert Pierrepoint who were engaged as hangman and assistant. In the meantime, an appeal was immediately launched on the prisoner's behalf, based on the fact that the judge had neglected to inform the jury that the victim would have been able to get out of the canal if she had stood up or shouted for help. No mention was made of the fact that Wyatt had gone back to the canal to try to find her, as the defence had mention when stating their case. Being unable to find her, Wyatt had returned home, changed his clothes and gone to notify the police.

Having considered all the evidence, the Lord Chief Justice, heading a panel consisting of judges Mr Justices Branson and Humphries, rejected the appeal and Wyatt was returned to Strangeways Gaol to await execution. A new date and time, Wednesday 18 May at 8 a.m., was fixed for his execution but six days before he was to go to the gallows it was announced that Wyatt's life had been spared and he was sentenced to life imprisonment.

Arthur Wyatt photographed on the day he was released from prison on 3 July 1945

In January 1944, while held at Parkhurst Prison on the Isle of Wight, Wyatt was injured whilst detailed to gardening duties, losing the tip of his left index finger in an accident with a scythe. He was later transferred to HM Prison Camp Hill from where he was released on licence on 3 July 1945. He had served just seven years and three months.

Wyatt returned to Bolton and found work as a labourer, but in May 1947, he found himself in court again when he was convicted of the theft of eight sheets of plasterboard. He was sentenced to three months' hard labour. Released later that summer, Wyatt continued to live in Bolton, dying at his home on Shepley Avenue on 11 December 1964.

CHAPTER 12

AFTER THE LAST DANCE

Like all other parts of the country, Bolton was observing the strictly enforced blackout as the war entered a crucial phase in the late autumn of 1940. Although the Battle of Britain had to all intents and purposes now ended, above the skies of Kent and the South East, as in London, the Luftwaffe had now embarked upon 'The Blitz', a sustained reign of airborne terror. Although bombs initially rained down mainly on the East End of London, and in particular the dockland regions, as further intelligence was gathered, often from spies and collaborators, the enemy began to seek out specific targets across the whole of the British Isles, forcing the whole country to be on the alert from air raids.

Whilst the blackout proved to be a hindrance and inconvenience to the majority of the law abiding general public, to the criminal fraternity it was treated as something of a blessing. Under the enforced darkness a thriving black-market was set up, with smuggling, larceny and other acts of petty lawbreaking becoming prevalent. The blackout also aided and abetted the murderer, allowing a higher number than usual to commit a dastardly deed and disappear into the darkness, avoiding detection and evading justice.

Police Constable Brooks was on routine foot patrol on Saturday evening, 16 November 1940. His beat took in the busy town centre, with the cinemas and music halls on Churchgate and along Deansgate to the pubs and cafés of Bradshawgate. As midnight fast approached he checked that the gates of the Queen's Cinema at the bottom of Trinity Street were securely locked before preparing to make his way back into town. He crossed at the junction of Bradshawgate and Lower Bridgeman Street and approached Bridgeman Place, a courtyard accessed under a stone archway, adjacent to the premises of Messrs. Parker's motor dealers, that was once the entrance to an old brewery.

Brooks routinely checked the back doors of premises leading into the courtyard and, as he approached, he shined his torch up the passageway beneath the arch. Immediately he made out a figure on the ground next to the garage. On closer inspection he found it was the body of a young girl lying on her back. Her clothing was in disarray and she was

Minnie 'Peggy' Stott

still wearing her gloves. Police Constable Brooks immediately summoned help, and detectives from Bolton C.I.D. hurried to the scene under the command of Detective Superintendent Harrison and Inspector Hodgson.

In the woman's handbag, recovered from beside her feet, police found a purse, containing a small amount of money, which seemed to rule out robbery as a motive and, from other papers in the bag, detectives learned that her identity was Minnie Stott, a seventeen-year-old grocery shop worker who lived at 124 Clarence Street, on the outskirts of Bolton town centre. Her parents, James and Alice Stott, were awoken with the news in the early hours, and her father was taken to the scene where he tearfully identified the body of his daughter before she was removed to Bolton Royal Infirmary for a post-mortem examination. A police surgeon certified that she had died from strangulation and an attempt at a sexual assault had been made.

Police investigations into her background revealed that Minnie Stott, known locally as 'Peggy', was a popular girl who, when not working as the manageress in the branch of Messrs Hanbury's grocery store on the junction of Elgin Street and Eskrick Street, loved to dance. Besides taking dancing classes at Aspen Hall, Peggy enjoyed spending time with her friends in many of the dance halls around the town.

Described as a pleasant girl, with a sober disposition, and with no regular boyfriend, tracing her movements on the Saturday night, detectives found that Peggy had finished work at sometime between 6.15 and 6.30 p.m. and made her way home. After tea she told her father she was going to 'the pictures' and headed into town. Shortly after 8 p.m. she called in to see her mother, on duty as a waitress in a town centre restaurant. Alice Stott told her daughter to enjoy her evening, and as they parted she smiled and added, 'Don't be late home!'

Peggy was last seen near the Balmoral Hotel by an old friend, who told police he had spoken to her and she was in the company of a man, with whom she seemed to have been quarrelling. Peggy's companion was described as being aged between twenty and twenty-five years old, average height and build with deep set eyes, high cheekbones and wearing a dark overcoat and trilby hat pulled well down on his forehead.

Detectives then learned of a meeting Peggy had had with a soldier two days before her death. In the company of a friend, Emily Wilkes, they had been at the 'Palais' on Higher Bridge Street, when during the interval they had left and gone to a nearby

chip shop. They fell into conversation with a man who claimed to be a soldier home on leave and that he was based in Newcastle. After eating supper they went to the Founder's Arms where the man bought both girls two glasses of sherry before returning to the dancehall. Emily said she had left Peggy and the soldier talking at around 10 p.m. and had never seen either again.

This was one of a number of leads detectives Harrison and Hodgson pondered. As one team of officers were sent to Newcastle upon Tyne, another was sent to Staffordshire to begin enquiries in Newcastle under Lyne. Police learned that there were eleven towns or villages called Newcastle in Great Britain and enquiries were carried out in all of them.

Enquiries also discovered that Peggy had called into a sweet shop on the evening of her murder. Sweet shop proprietress Mrs Ince, of 62 Bridge Street, told officers that at around 8.30 p.m. on the Saturday night she had sold two quarters of dragees — sugar and chocolate coated almonds — to two young girls. A bag of this type of sweet was found in the dead girl's handbag. Pleas in the press for the other buyer of the sweets failed to draw any leads, and this line of investigation soon came to nothing.

Another avenue police followed was to trace the identity of the owners of a photograph found in a drain close to where the body had been discovered. Showing a young girl and friends in 'Whit' week costumes, there was again no response to an appeal for the owners to come forward. Nor was there any response to an appeal made to trace an overcoat, the label of which was found in the courtyard close to the body. Although the raincoat was traced to a store in Bolton, finding the owner proved impossible and again this enquiry petered out.

In the meantime, a soldier came forward to say he had been with Peggy on the Thursday night at the Palais and the chip shop, and he was soon able to satisfy detectives of his innocence in the murder and enquires then focused elsewhere. The photograph was also eventually eliminated from enquiries when a witness came forward and claimed the photograph belonged to them and had no connection with the murder.

What detectives hadn't made public in the first press releases was that Peggy had been strangled with her own green crepe de chine scarf and, more significantly, also missing was the pair of blue cami-knickers Peggy had been wearing before her death and which had been found to be missing at the post mortem.

Minnie Stott's funeral took place a week after the murder and, as she was laid to rest at Heaton Cemetery, detectives mingled with friends and family as they paid their respects. A few weeks later her heartbroken parents were visiting the grave when a woman approached, claiming she had some information that might help solve the mystery of Peggy's murder.

The woman said she had seen Peggy and a woman climb into a car with two men. She even gave them names, which the Stotts passed on to the police. As with all other leads in

The archway on Bradshawgate where Peggy Stott was murdered

this investigation, this amounted to nothing, and, with the country struggling to survive in the face of the enemy overseas, the investigation was reluctantly scaled down.

Minnie Stott met her death at a time when the country was at war and under an enforced blackout, and with a vast army of servicemen moving around the country on a daily basis. For her murderer this proved to be the perfect cover. Detectives reasoned that perhaps he been a soldier in the town on leave, or stationed nearby, and may simply have made acquaintance with Minnie Stott on that fateful night. He probably engaged her in conversation and she agreed to accompany him away from the dancehall, perhaps to the station where he was to meet a train. On the way they had ventured into Bridgeman Square where he had forced himself upon her. When she resisted his advances he had turned violent and, after committing his crime, he had simply caught a train away from the town to rejoin his unit and perhaps a posting overseas.

Although no unsolved murder case is ever officially closed, with almost seventy years having passed since Minnie Stott was cruelly slain, it would now seem highly likely that the killer, like his victim, has already gone to a better place, and the mystery as to who committed a brutal murder that cold November night in 1940 will never be solved.

CHAPTER 13

IN DESPERATION

They had been married for just one week before the young soldier was sent overseas. It was the spring of 1942, and no sooner had the couple entered into wedlock and moved into her parents' house at 189 Fern Grove, Bury, than Sam Bridge was posted to North Africa, joining the 'Desert Rats' in the fight against Rommel.

His wife, twenty-two-year-old Rose Bridge, like thousands of other wartime brides was also doing her bit to help King and country by finding a job in a local munitions works. Soon, word reached her that her husband had been taken prisoner whilst fighting in Tunisia, and although he managed to escape from custody in Italy, Bridge was later interred in Switzerland.

The rationing, blackouts and other hardships brought on by the war meant that holidays were something of a rarity, but at the end of June 1943, Rose Bridge decided to take a holiday on her own to Blackpool. It was here that she made the acquaintance of a member of the Royal Air Force, home on leave. Whether it was a one-night stand or a holiday romance wasn't made clear from press reports of the trial in the thin wartime newspapers, but this brief union did result in Rose Bridge later finding herself pregnant.

At Christmas-time 1943, Rose confided in Annie Morley, a friend and workmate at the munitions factory, and told her that she planned to get the baby adopted once she had given birth and, although she also told her mother, fifty-seven-year-old Lilian Staniforth, a cleaner at the Art Cinema in Bury, her condition was kept secret from almost everyone else. Rose and her mother were particularly keen to keep the news from her father, an invalid, in frail health, whom they believed would be traumatised by the news. They did manage to keep it a secret from her father and, although he did have his suspicions that something was amiss, they managed to convince him there was nothing to worry about.

She had to give up work after Christmas and by the spring of 1944, Rose's condition was obvious to all except her father. On the morning of Thursday 6 April, she checked into the Havercroft Maternity Home on Victoria Road, Bolton. She gave birth to a baby boy at 8.50 p.m. that night and stayed at the home until

The Ainsworth Arms, Radcliffe, formerly known as the Three Arrows

Wednesday 19 April when she was discharged and, after being collected in a taxi by Mrs Morley, went to her house on Barrie Way, Bolton. Mrs Staniforth arrived at the house at 1 p.m., and after a cup of tea the mother, grandmother and baby boy left the house, having told Annie Morley they were going to get the baby adopted. At Rose Bridge's request Annie had purchased some clothes for the baby and she dressed the child but, on account of the terrible rain, Mrs Morley gave her a brown rubber coat and white cot blanket which they wrapped around the baby before the left the house.

During the afternoon and evening they travelled into Manchester and made an unsuccessful attempt to get the child adopted, even taking to approaching a woman in Albert Square and asking her if she wanted to adopt or knew anyone who did, before they reluctantly returned to Bolton. A visit to the National Children's Home at Edgeworth also proved fruitless, with the manager telling the women that they were unable to take in any children under the age of five.

At 8.45 p.m. they boarded a bus at Bolton terminus, heading towards Bury. Conductress Jennie Shatwell recognised the mother and daughter, having previously been neighbours, and noticed that the daughter seemed to be carrying a baby, which

Rose Bridge

was done up more like a parcel than a child. Passengers on the bus also remarked on the child, including Phyllis Lakeman who received a frosty response when she asked Rose Bridge if it was a baby she was holding.

When the bus reached the Three Arrows Hotel, Ainsworth, Rose Bridge, her baby and Lilian Staniforth alighted and crossed Starling Road. It was still raining heavily, and twenty minutes later the two women were in the hotel where they enquired about the next bus to Bury. When barman Harold Taylor told them he believed they had missed it, they ordered two glasses of port and then asked Taylor to order them a taxi. When he was unable to summon a cab the two women finished their drinks and set out to walk the two miles to Bury.

At 7.55 a.m. on the following morning Robert Kirkman, a cleaner, known then as a scavenger, employed by Radcliffe Corporation, entered the ladies lavatories and spotted what he thought was a napkin. On closer inspection he saw it was a baby's bonnet. The toilets were all coin operated and normally locked, but one was open and as he pushed open the stall doors something prevented it opening further. When Kirkman entered his first thoughts were that it was a doll behind the door but it soon became clear it was the body of a baby.

Lilian Staniforth

He immediately summoned the police and Police Constable 1155 William Dobson was at the scene in minutes. He quickly ascertained that the child was dead. Detectives soon arrived in the company of pathologist Arnold Renshaw. A post mortem was carried out at Bury that morning and found that the body was that of a young boy aged about three weeks, and that cause of death was due to heart failure due to being hung upside down with its head submerged in the toilet bowl. This had been accelerated by concussion due to bruising and also shock.

Details of the discovery of the baby's body made the headlines of that night's newspapers and, when a report was made of the garments found on the body, information led police to suspect that the baby was that born to Rose Bridge. Enquiries were made, and at 3 p.m. on Friday 21 April, Detective Inspector Ingham and Detective Sergeant Francis Stansfield called at a house on Kingfisher Drive where they spoke to the two women. Told by detectives they were investigating the discovery of a baby in the public lavatory on Starling Road, Rose Bridge replied, 'Yes it is my baby. I left it there. I am going back for it now.'

Both were cautioned and taken to Bury Police Headquarters where they were questioned separately. During the interviews detectives heard that attempts had been

Any communication on the subject of this letter should be addressed to :—

THE UNDER SECRETARY OF STATE,
HOME OFFICE,
LONDON S.W.1.

and the following number quoted :—

885,419

HOME OFFICE,

WHITEHALL.

6th July 1944.

Sir,

 I am directed by the Secretary of State to inform you that he has had under his consideration the case of Lillian Staniforth and Rose Bridge, now in the Prison at Manchester under sentence of death, and that he has advised His Majesty to respite the capital sentence with a view to its commutation to penal servitude for life.

 I am, Sir,

 Your obedient Servant,

 J. aNewsaus

The Director of

 Public Prosecutions,

 Devonshire House, (East Entrance),

 Mayfair Place,

 W.1.

Letter notifying the prison governor that a reprieve had been granted

made to strangle the child before it was drowned in the toilet bowl and left on the floor. The two women were then charged with murder to which Bridge replied, 'We didn't kill him, he was alive when we left him.' Lilian Staniforth confirmed this by claiming, 'He wasn't dead when we left him.'

 Both were remanded in custody, being refused bail, and on the following Friday 28 April, they appeared at Bury County Justice Court. Mr H. Trevor King appeared

H.M.Prison.
Manchester.

7th July 1944.

Dear Sir,

2345, Lillian Staniforth.
2346, Rose Bridge.

I beg to inform you that the sentences on the above named prisoners have been respited, and that the arrangements made for Tuesday, the 11th instant, have been cancelled. Kindly return the Railway Warrant sent to you yesterday.

Yours faithfully,

Governor.

Mr.H.W.Critchell,
Devonshire Arms,
Moreton Street,
Pimlico,
London S.W.1.

Daughter Burnt Baby in the Copper Fire. and buried the Baby in the Garden.

Letter addressed to assistant hangman Harry Critchell notifying him his services were not needed. Critchell noted erroneously on the letter how Bridge had killed her child

for the Director of Public Prosecution, while the defence was handled by Mr George Clough of Bury. The prosecution's case was that the murder had been committed with deliberation and in 'circumstances as callous and brutal as it is possible to imagine.'

Both the accused took the stand and each made a statement. Rose Bridge simply said, 'I did not know what I was doing…. We couldn't take the baby home for the shock would have killed father.' Her mother's testimony was much the same: 'We did not know what to do with him, and I daren't take him home… I was so upset that I

did not know what I was doing... my mind was in a whirl.' Satisfied that there was a *prima facia* (based on first impression) case, both were committed to stand trial at the forthcoming Manchester Assizes scheduled to begin on Tuesday 2 May.

On Wednesday 3 May, Rose Bridge and Lilian Staniforth found themselves before Mr Justice Hilbury. Mr A. E. Jalland led for the prosecution assisted by Trevor King, while the solicitor handling the defence had engaged Mr Neville Laski, KC, to represent both the accused.

As at the committal hearing the prosecution claimed it was a pre-meditated case, a murder committed to be rid of the unwanted burden of the child. The defence claimed it was 'a pathetic case' committed by a woman who had recently given birth to a child she had neither planned for nor wanted. Laski claimed that Rose Bridge was beset by the most harrowing anxiety following the birth of the child, and her desperation, being unable to get the baby adopted, had resulted in the actions that had led to murder. Laski asked that the charge be one of infanticide against the mother and manslaughter against the baby's grandmother, who had yielded to the twin desires, to assist her daughter and shield her invalid husband from discovering the truth about what had happened.

The one-day trial ended with the judge summing up for over an hour, and although the defence had claimed that both women were 'worried out of their minds', he made it clear to the jury that this was not the same thing as insanity and asked the jury to consider their verdict. They needed just fifty minutes to find both guilty of murder, adding that they strongly recommended that mercy be shown.

With the black cap draped on his wig, Mr Justice Hilbury sentenced Rose Bridge and Lilian Staniforth to death. Both collapsed as they heard the judge condemn them to be hanged. They were taken to Manchester's Strangeways Gaol and letters were sent out to the hangman and his assistants requesting their services for the date fixed initially for Tuesday 23 May. An appeal was soon launched and this shifted the original date. The appeal hearing in London merely looked at the aspects of the trial and, as there was no question of any fault in the evidence or judge's summing up, the appeal was dismissed and a new date of Tuesday 11 July at 9 a.m. was set for execution.

No woman had been hanged in Great Britain since 1936, and there had not been a double execution of two women since 1903. It was thought, by representatives of the two women, that a reprieve would soon be forthcoming, but as the date of the execution loomed there was still no word that clemency would be shown. Finally, five days before they were due to hang, a reprieve was granted and both women were sentenced to life imprisonment. Life in this case was to be just four years and four months, with both being released on 13 September 1948.

One wonders on each of those nights she spent awaiting the hangman, and then whilst serving the prison sentence, if Rose Bridge rued that night of passion in Blackpool that was to have such dreadful consequences?

The trial of Rose Bridge and Lilian Staniforth was something of record in terms of the speed in which events moved. From the discovery of the crime on Thursday 20 April it took just fourteen days before sentence of death was passed. It is doubtful, before or since, that a verdict on a murder trial was passed so soon after the crime was discovered.

CHAPTER 14

VANISHED WITHOUT A TRACE

While members of the allied forces were planning their next moves in the European theatres of war, at her home on Macdonald Avenue, New Bury, six-year-old Sheila Fox's plans probably involved spending the weekend playing hopscotch, top and whip and perhaps skipping in the sunshine, as a late summer heat-wave bathed the whole of Lancashire in warm sunshine. As school ended for another week at 4 p.m. on the afternoon of Friday 18 August 1944, Sheila left her schoolmates in Class 2 at St James's Primary School and set off for her home a few hundred yards away. She never arrived home and a mystery began that remains unanswered to this day.

Smartly dressed in a blue flower patterned frock, with green coat, brown stockings and shoes, and with pink ribbons in her hair, Sheila was last seen riding on the cross bar of a bicycle ridden by a man in a blue suit. Asked by one of her classmates where she was going, Sheila replied, 'I am going with this man.' When she failed to return home by nightfall her worried family began searching the nearby streets, frantically calling on her school friends to see if they knew of her whereabouts.

The police were notified and officers searched air-raid shelters, outbuildings, fields and hedgerows but without success. The search escalated over the weekend as volunteers joined the hunt, which widened beyond Farnworth and New Bury. A number of sightings were reported to detectives but each proved to be a false alarm. Her photograph was shown between features at local cinemas and police posted a missing persons notice outside police stations and in public places in which a description of the man with the bicycle was published. He was described as being aged twenty-five to thirty years old, slim long face with sharp features, fresh complexion, clean-shaven with dark brown hair and wearing a blue suit with a collar and tie.

Sheila was the youngest of five sisters and her parents Miriam and George Fox told officers their daughter was so shy around strangers that she must have known the identity of the man on the bicycle. This suggested the man was local. One sighting the police followed up was given by a witness who claimed to have a seen a girl wearing a green coat and with pink ribbons in her hair on the handlebars of a bicycle ridden by a man who matched the police description of the wanted man. They were last seen

New Bury Community Learning Centre — formerly St James Primary School where Sheila Fox attended

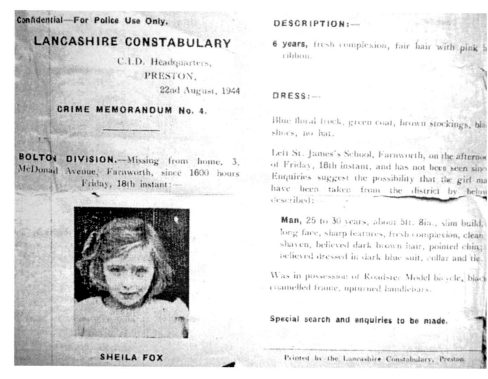

Confidential—For Police Use Only.

LANCASHIRE CONSTABULARY

C.I.D. Headquarters,
PRESTON,
22nd August, 1944

CRIME MEMORANDUM No. 4.

BOLTON DIVISION.—Missing from home, 3, McDonald Avenue, Farnworth, since 1600 hours Friday, 18th instant:—

SHEILA FOX

DESCRIPTION:—

6 years, fresh complexion, fair hair with pink ribbon.

DRESS:—

Blue floral frock, green coat, brown stockings, black shoes, no hat.

Left St. James's School, Farnworth, on the afternoon of Friday, 18th instant, and has not been seen since. Enquiries suggest the possibility that the girl may have been taken from the district by below described:—

Man, 25 to 30 years, about 5ft. 8in., slim build, long face, sharp features, fresh complexion, clean shaven, believed dark brown hair, pointed chin; believed dressed in dark blue suit, collar and tie.

Was in possession of Roadster Model bicycle, black enamelled frame, upturned handlebars.

Special search and enquiries to be made.

Printed by the Lancashire Constabulary, Preston.

Police notice relating to Sheila Fox's disappearance

heading away from Four Lane Ends down Newbrook Road, toward Atherton. It was the last sighting but like other leads it came to nothing.

Although the disappearance of the young girl was headline news in the local area, the newspapers of the time were very thin due to paper shortages, and with the war raging around the world, other events soon pushed the story off the front pages and it was overshadowed when a bomber crashed into a school during a storm, just thirty miles away, at Freckleton, killing thirty-eight children and twenty-two adults. Gradually the search was wound down and the file, although not closed, was left to gather dust in the pending tray.

The dust was brushed off the file in the summer of 2001 when new information was passed to police officers in Bolton. Detective Superintendent Dave Jones and Chief Inspector Paul Buchanan were put in charge of the investigation when it was learned that a sixty-seven-year-old man had made a deathbed statement that he had witnessed a neighbour at his house on Barton Road, Farnworth, digging a hole in his garden late on the night that Sheila had disappeared.

The man he named was Robert Ryan, a convicted rapist who had also been charged with the indecent assault of a child in 1965. Ryan, a miner, had left the house on Barton Road in 1948, two years before he was charged with rape. He had been twenty years old at the time of Sheila's disappearance and had since died.

Armed with this new information, Superintendant Jones assembled a team of senior detectives, scene of crime officers and two forensic archaeologists and descended on Barton Road shortly after dawn on Tuesday 5 June. In what was described as a very labour intensive search, detectives painstakingly removed earth to depths of over a metre in some places, deeper still in others. Once news of the search made the headlines, elderly residents in the area told reporters they felt the police search was a waste of time, mainly because some twenty-five years before a massive operation replacing sewer pipes in the area resulted in bulldozers ploughing up these very same gardens, and they believed that if Sheila had been buried where the police were searching, her remains would have been dug up then.

Perhaps they were right. The new search failed to solve the mystery and the file was replaced in the unsolved pile. Unsolved murder cases are never officially closed, but it is unlikely now that Sheila's relatives will get the closure they hoped the 2001 investigation would give them and allow the missing girl a Christian burial.

Less than a year later, in 1945, another young girl, six-year-old Patricia McKeown was attacked by a knifeman in St James Street. Then, in March 1948, a man accosted another six-year-old girl, Brenda Hume, as she walked home from St James's Primary School. In this assault the attacker cut the youngster several times across the arms and upper body with a knife before she managed to escape and raise the alarm. The knifeman was pursued across open fields but was never caught.

These last two youngsters both escaped with their lives, but it would be just a matter of weeks before Farnworth was again the centre of a police investigation, only this time they would be hunting a murderer.

CHAPTER 15

STREETS OF FEAR

Macdonald Avenue in the New Bury district of Bolton was a street in fear. Fate seemed to have singled out this row of modern, neat, red-brick semi-detached houses and it had already been headline news following a series of attacks on children in the previous years, when in Easter 1948, shortly after another attack on a young girl in the area, the grim reaper finally cast his cloak of death across the frightened streets.

At shortly after 5.30 p.m. on the afternoon of Monday 12 April 1948, friends eleven-year-old Queentin Smith and nine-year-old David Lee were playing on fields off Plodder Lane, beside a bridge that spanned the Bolton to Manchester railway line. As they enjoyed the spring sunshine, the boys lit a number of small fires on the railway embankment, when they were suddenly approached by a man who claimed he worked for the railway and told them they were in trouble.

Although both boys had been warned by their parents not to talk to strangers, with all parents being on full alert following the disappearance of Sheila Fox and the attacks on the other children, they believed the man was a railway employee, and as they had technically been doing wrong by lighting fires, they were perhaps scared of being punished and meekly followed his lead.

The man led them away from the fires onto another embankment where he then told David to 'lie down there!' He then pulled out a knife and attacked both boys, injuring David who managed to stagger away as he continued his murderous attack on the older boy. Neighbours saw David crawling towards his home on Macdonald Avenue where he was able to tell his parents he had been attacked by man on the embankment. The police were summoned and making their way to the spot off Plodder Lane they found the partially naked body of Queentin Smith. He had been stabbed and battered to death. By the time officers arrived the attacker had fled.

David was taken to Bolton Royal Infirmary where he was treated for stab wounds to his chest and lower abdomen. Once his condition was made comfortable he was able to give police a description of his attacker whom he described as being a tall, thin young man, with deep-set eyes and a spotty face. There were clear similarities in

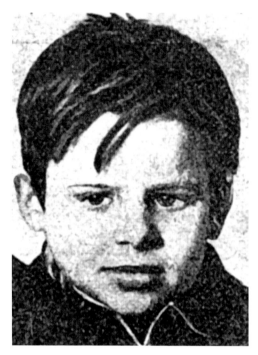

Jack 'Queinten' Smith

the description of the killer and the man who was being hunted in the disappearance of Sheila Fox who, like David Lee, also lived on Macdonald Avenue.

Detective Superintendent John Woodmansey of Lancashire Constabulary handled the investigation and he assigned over a hundred detectives to the hunt for the killer. In the area close to where the attack had taken place officers combed the fields with metal detectors, while four local lakes were drained in an attempt to locate the murder weapon.

Detectives described the injuries sustained by both boys as the work of a sexual maniac. There was even speculation among detectives that the recent full moon may have been responsible for the killer's behaviour.

Queintin lived with his parents, Jack and Nellie Smith, on Bradford Road Farnworth and attended Marsh Lane Primary School. He was a bright, intelligent lad and had just sat his eleven plus exam, which would determine whether he would be eligible to go to grammar school in the coming September.

With the murder enquiry gaining little in the way of success, the chief constable of the Lancashire Constabulary decided to call in the assistance of Scotland Yard and Liverpool-born Detective Chief Inspector Jack Capstick and his assistant Detective Sergeant John Stoneman made their way up from London to take over the investigation.

Despite working around the clock for over a month they were no closer to finding the killer, and by the middle of May the two Scotland Yard detectives handed

back the investigation to their Lancashire colleagues and returned south. Capstick wrote later that no sooner had he returned to London than the telephone rang and he was summoned back to Lancashire to handle the investigation of the murder of a young girl in Blackburn.

In the early hours of Saturday 15 May, the body of a three-year-old girl was found brutally murdered and sexually assaulted in the grounds of Queen's Park Hospital, Blackburn. Her killer had made his way into the ward where she was recuperating from a case of pneumonia, removed his shoes and snatched her from her cot and carried her out into the grounds where he committed a brutal rape and murder, as vile a crime as recorded in history.

David Lee photographed recovering in hospital

Detectives found a fresh set of fingerprints on a 'Winchester' bottle beside the bed, used to hold distilled water and, believing these prints belonged to the killer, Capstick ordered that every man between the ages of sixteen and ninety who lived in Blackburn be fingerprinted. This unique investigation involved the taking of around fifty thousand sets of fingerprints before a match was found and led to the arrest of twenty-two year old Peter Griffiths, an ex-guardsman who worked as a packer in a flour mill.

Griffiths was convicted at Lancaster Assizes of the murder of the young girl and sentenced to death in October 1948. Shortly before he was hanged at Liverpool's Walton Gaol, David Lee was taken to view the prisoner but told detectives he thought Griffiths was taller than the man who had killed his friend. Although Griffiths went to his death denying his involvement in the disappearance of Sheila Fox, the murder

David Lee accompanies detectives in the hunt for clues

Detective Chief Inspector Jack Capstick of Scotland Yard

of Queintin Smith and the other attacks on children in Farnworth and New Bury, Capstick believed that he was responsible and when he published his autobiography in 1959 he wrote 'I am convinced that he took with him the secret of the "mad moon killer" of Farnworth. There were no more child murders in Farnworth.'

Whilst it may be true there were no other murders, it was not the end of the attacks on children in the area, with reports appearing in the press in the early 1950s, and again in the 1960s and early '70s.

In 1976, new evidence led to police re-investigating the murder of Queintin Smith. Officers sought new information after it was suggested that the killer might have been in the area in response to an advertisement placed in a national magazine for a vintage motorcycle offered for sale a few days before the murder was committed. The investigation quickly fizzled out and the case was never solved.

Sadly, two weeks after his brutal murder, a letter addressed to Queintin Smith arrived at his house stating he had been successful in his exams and had won a place at grammar school. His parents later had two more sons who were both schooled in Bolton before they emigrated to Australia. Queintin's friend David Lee remained in the Bolton area, and, for over a year after the attempt on his life, he was given police protection in case the killer should return.

When interviewed by local reporters in 2001 following the police's re-investigation into the disappearance of Sheila Fox, David Lee said that although he still thought about his friend now and again he didn't think about it too much as he wouldn't have really had a proper life. He also believed that the killer would be dead now anyway.

CHAPTER 16

IN SELF-DEFENCE

By the autumn of 1950, William Clifford Kay and Irene Hailwood had been living together as man and wife for six years. Irene had divorced after a three-year marriage and had even gone as far as changing her name with the Food Office, in charge of issuing rationing books etc, and was now known as Irene Kay. A twenty-eight-year-old mother of two young children, aged five years and twelve months old, she shared a house at 42 Commission Street with thirty-five-year-old Kay, employed by William Gornall and sons of Ellsemere Street as a lorry driver.

Kay was a man known to the police for his violent character: he had several convictions for being drunk and disorderly and assaulting a police officer and was a heavy drinker who, when drunk, would often subject his wife to tirades of foul language, occasionally resorting to violence.

At 7.45 p.m. on the night of Sunday, 3 December 1950, the couple went out drinking in Bolton town centre. They were seen by friends and appeared to be on good terms. On reaching town they split up; she went to meet friends in the Swan vaults, while he headed for the Grapes Hotel on Victoria Square, where Irene joined him as closing time approached.

Although both had been drinking, friends didn't think either of them was that drunk when they left for home together after last orders had been called. They purchased supper, which they finished at home, and it was as they prepared to go to bed that Kay turned on her and asked if any other men had bought her drinks while she was in The Swan Hotel. She said not and they quarrelled briefly before Kay stormed upstairs to bed.

Irene Kay, having checked on the two children, picked up a book and sat in an armchair reading by the fire. Suddenly Kay came back downstairs, grabbed Irene by the hair and slapped her about the face calling her names. Whatever had caused this outburst, Irene began to fear for her safety and, as Kay continued his abusive attack, she managed to struggle to her feet and backed away to the kitchen table where she picked up a carving knife and turned towards him wielding the knife in front of her.

Kay scoffed and lunged forward only to impale himself on the knife. He pulled away and then slumped to the ground moaning. Irene dropped the knife and in a panic she hurried from the house and knocked on the door of her neighbour, Lily Nicholson, who lived at 32 Commission Street.

'Lily, please come and help me. Come and look at Bill. There is something wrong with him. We have been fighting.'

When the two women returned to the house Kay lay still in a pool of blood on the floor between the couch and the fireplace.

'What have I done to you, Bill?' Irene pleaded over and over as her friend summoned the police. Police Sergeant Barton and Police Constable Tanfield were the first to arrive, and entering the house they found Irene kneeling on the floor cradling the head of William Kay who seemed to be already dead.

A police surgeon confirmed this was the case and when pathologist George Bernard Manning conducted the post mortem on Monday afternoon, he found that cause of death was due to a single stab wound just below the heart. He did note that there was one other wound to the chest, a tiny cut that had barely drawn blood.

Irene Kay was taken into custody and charged with wilful murder, and while the post mortem was being carried out she made the first of a number of court appearances. Appearing before Mr E. Fielding, the Borough Prosecutor, she was assisted into the court by a policewoman. Clearly in shock, she appeared dazed and was weeping when asked if she had consulted a solicitor. She weakly whispered 'no' to the question, and when asked if she would like legal aid she said she would.

Remanded into custody for a week, Irene Kay made several more appearances in the run up to Christmas, as the prosecutors prepared their case, and when, after a fourth remand was ordered, Mr Goulding, representing the prisoner, objected, stating, 'The prisoner is very upset and would like the case to be disposed of as early as possible.'

The case finally came to the high court on Monday 12 March 1951 when Irene Kay appeared before Mr Justice Donovan at Manchester Assizes on a charge of manslaughter. Prosecuting counsel Mr W. G. Morris stated that they believed the accused had committed a violent attack and although her counsel claimed she had acted in self-defence, Morris asked the prisoner, 'Do you really think that this man was going to take your life that night?'

'Yes, Sir', she replied.

The defence believed they had a strong case but they had a few shaky moments, none more so when under questioning Irene Kay said that on the night of the stabbing, William Kay had said, 'I'll swing for you.'

The prosecution were quick to jump onto this suggested provocation and asked her why she had failed to mention this during the three-hour interview with detectives following her arrest. She couldn't explain why not and she also had to agree that William Kay had good eyesight along with a very bad temper.

Murder charge reduced

BOLTON WOMAN TO BE TRIED AT ASSIZES

"I am absolutely innocent of this charge," said Irene Kay (28), 42, Commission-st., Bolton, after the Bolton Borough Magistrates, by a unanimous decision, had committed her for trial to the next Manchester Assizes yesterday on an indictment of manslaughter.

Cutting relating to the death of William Kay

Mr Goulding stated in their defence that 'The prisoner has a complete answer to the charge — in short one of self-defence — and you can picture her with two children, one five and one twelve months, for whom she is most concerned.'

When Mr Justice Donovan began to sum up the case it seemed clear that he sided with the prosecution. Although he stated that the victim was violent and foul mouthed especially when he had been drinking. He said that the accused was in a difficult situation, having two young children, no money, no occupation and nowhere to go should she chose to leave.

He referred to the two wounds found on the victim, asking if it was credible to believe that having felt the knife against his chest, which had caused the first minor cut, he would then lunge forward and impale himself on the blade.

'In this case' the judge stated, 'you could say the brute had provoked this woman beyond endurance and has only got himself to blame. But, these are not the facts relating to a charge of manslaughter. If two people struggled and one person provoked beyond endurance, snatched up a knife and held it in front and kept it there so he ran up onto it, the jury would have good sense to see as being just as culpable as pushing the knife.'

He asked the jury if they were satisfied it was an accident, but if not they could consider self-defence. They needed forty-five minutes to reach a verdict, returning to find her guilty of manslaughter. Irene Kay collapsed as she was sentenced to three years' imprisonment.

'I hope I am not being too lenient with you', the judge said as she was ushered from the dock.

An appeal was launched and was heard at the Central Criminal Court on Monday 11 June. Before the Lord Chief Justice and Justices Lynskey and Devlin, they were told

that the defence put forward at the trial was that the appellant had been assaulted, and had picked up a carving knife in the hope of deterring her assailant, who had rushed on the knife and so inflicted on himself the injuries which caused his death.

The Lord Chief Justice in giving his judgement to the court said that the conviction could not stand in view of the judge's direction to the jury. The defence had never been put properly to the jury in that direction, and, if it had been, he (his Lordship) thought that the jury would have come to another verdict. As a result the appeal was allowed and Irene Kay's conviction was quashed and she was immediately set free to rebuild her shattered life.

CHAPTER 17

NO MOTIVE OR ANYTHING LIKE THAT

Miner Frederick Broad had just finished the night shift manning the pumping station at Wharton Hall Colliery, Tyldesley, when he set out towards his home on Wigan Road, Atherton. It was a little after 6 o'clock, Sunday morning 8 April 1951 and as Broad and several workmates made their way across a field, they saw what appeared to be a body lying close to the fence near to the boundary stone separating Little Hulton and Tyldesley, less than ten feet inside the Tyldesley border. On closer inspection they saw it was indeed the body of a young woman, covered with a raincoat and with a white silk scarf tied tightly around her neck. Her brown plastic handbag was lying at her feet.

The police were quickly notified and Detective Superintendent Lindsay, the Chief of Lancashire CID, was soon at the scene, accompanied by a number of senior officers who set up their headquarters at Tyldesley Police Station. The body was identified as Mona Mather, a twenty-eight-year-old cotton mill doubler who lived with her parents at Wharton Fold, and a post-mortem, carried out by Dr A. C. Carragher at Warrington Infirmary, found that cause of death was manual strangulation.

By noon, detectives had learned that on the previous night Mona had been seen drinking with members of her family in the George and Dragon pub in Tyldesley until around 10.30 p.m. when she left with a man. They were then seen together at 11.40 p.m. on the fairground on nearby Shakerley Common. They learned that the man was Jack Wright, a thirty-year-old screen hand at Astley Green colliery, who lived at 3 John Street, Tyldesley, and following a short manhunt Wright was picked up in Manchester less than eighteen hours after the body had been discovered. Taken to Leigh police station, he was cautioned by Detective Chief Inspector McCartney before making a detailed statement, which explained in his own words what had happened on the night of the murder:

Well, story starts a long time back — last September — that's the first time I went with her. I don't know why but I intended doing then what I've done now, but when I was out with her in September a chap came up talking to us for a while and it was raining hard

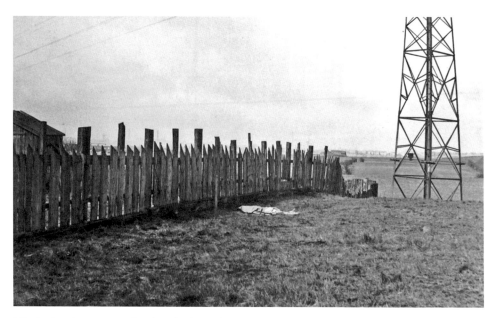

The body of Mona Mather beside the colliery fence

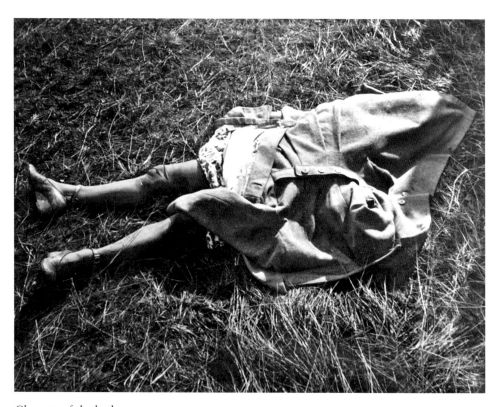

Close up of the body

TYLDESLEY MURDER TRIAL

DEATH SENTENCE FOR GIRL'S STRANGLER

Court story of fourth attempt

After being out for 2¾ hours at Liverpool Assizes on Tuesday, a jury of 10 men and two women found Jack Wright (30), colliery surface hand, 3, John-st., Tyldesley, guilty of the murder of Mona Mather (27), Wharton Fold, Little Hulton, and he was sentenced to death by Mr. Justice Oliver. A psychiatrist had previously said that in an hour's conversation with Wright at Walton Prison the week before, Wright had told him he had made three previous attempts to strangle women. Twice he had left them unconscious.

Wright was represented by Mr. Robinson Chichton, K.C., and Mr. Leslie Rigg, instructed by Mr. G. E. Hope. Mr. H. I. Nelson, K.C., and Mr. J. M. Davies, rosecuted.

When Wright was charged, he pleaded guilty, but after his counsel had explained to Justice Oliver that Wright had not fully [...]

Wright on the wakes with the dead woman said he joked with Wright saying "Well, Jackie, I didn't know you were courting." Wright replied: "No, it's one I have picked up."

Wright's stepfather, James Hurst, with whom he lived, told counsel that Wright seemed just [...]

just felt the impulse to do it and did it."

Dr. Vaillant said that when he asked Wright if he enjoyed it he replied· "I had a strong feeling of satisfaction. After, I just became normal. I had a meal and went to bed." He did not have this feeling just towards this particular woman, but to any woman. Wright told him he knew what he was doing at the time and that he took a delight in it.

Asked if he had ever done anything like it before Wright told witness he had done it to several women before. "One previous to this I thought maybe she was dead," he was alleged to have said. "I left her. She was out like and I just left her." On two occasions he said he had [...]

he would do something and not see the significance of it.

Not perfectly normal

Dr. Vaillant resumed his evidence on Tuesday, and said he did not think Wright was a perfectly normal man. He did not appear able to have distinguished between right and wrong when the offence was committed. He thought Wright's disordered mind would drive out any question as to whether he was acting in accordance with the law or not.

If Wright had presented himself at hi . . c. Vaillant said, and an ar ation had disclosed . i· the state of his mind—q. art from anything to do with the strangulation of the woman—he would have asked him to put himself under observation. Operative treatment for the trouble necessitated the snipping away of part of the brain.

Cross-examined by Mr. Nelson, Dr. Vaillant said he thought Wright appreciated that it was wrong to strangle a woman while trying to rape her.

When Mr. Crichton objected that no evidence had been presented about rape, Justice Oliver said there was every evidence in the torn underclothing etc.

News cutting relating to the murder of Mona Mather

so I left her and went home. I've never seen her since then up to Satday night. I saw her in't George and Dragon about twenty past ten — maybe half past ten. I came out and she came out after. I talked to her outside t' Dragon for a minute, just asked her like if she wanted to have a walk onto t' wakes

She said so, so we went onto t' wakes together. We spent about an hour on there, going on to t' Moon Rocket and different things, them cars and things like that. I've always had it into t' back of my mind to do a job like this, but I never put myself out of my way to get a woman to do, so when I was out on t' wakes with this one I made my mind up to walk her home so that I could finish the job off proper. It was about twelve o'clock or that road on when we left t' wakes and we walked along Common Lane past the brickworks and over the railway bridge. We got to t' farm on the other side we turned up the footpath that goes to Wharton Hall Colliery. Then we got past t' pit I said we'd stop against t' boards there. That seemed best shop to me for't job. We stood against t' boards for a couple of seconds and then I grabbed her by the throat. She hadn't time to do anything. She couldn't speak. I squeezed her throat with my hands and after a minute she went limp, and went dead weight against my hands. Then I heard some voices coming up t' lane from t' same direction as we come. So then I carried her up alongside the boards into the middle of t' field at the back of the colliery. She was just lying unconscious then, but she was still breathing so I lied her down on t'ground and got hold of her scarf. I just

Executioner Albert Pierrepoint hanged Jack Wright at Strangeways Gaol on 3 July 1951

tied it around her neck and held it until she stopped breathing. I hadn't anything against her: it just had to be her that's all, there's no motive or anything like that. I had to hold the scarf for about three minutes before I was sure about t' job. I took her coat off then and straightened her out against t' boards. I put her coat across her and then walked back the same way as we come. I got home about a quarter to two and had my supper. I had to cut my own — two or three slices — and then I went upstairs to bed.

And t 'rest of the story I reckon you know. I went out about a quarter to twelve and went to the top of the street to t' Market Place. After opening time I went to t' Liberal Club and had a pint. From there I went to t' Legion and a mate of mine told me that Detectives had been in looking for me. I weren't bothered, because I knew it had to come, but I thought I'd make it last as long as I could, so I went down Astley out of the way for a pint or two. After closing time I catched a 'bus to Manchester and went t' pictures at that French place in Market Street. I thought I might as well go t' pictures while I had t' chance. And that's all there is to it. I was having a drink of tea in one of the buffets at London Road when t' Railway Detectives picked me up.

<div style="text-align: right">

Jack Wright

9 April 1951

</div>

Wright offered a plea of not guilty on account of insanity when he appeared before Mr Justice Oliver at Liverpool Assizes on 12 June. Dressed in a blue suit and with his fair hair well brushed, Wright sat motionless throughout the trial, with his arms

folded across his chest. His defence counsel, Mr J. Robertson Crichton, KC, called Dr C. M. Valliant, MA, MB, consultant psychiatrist at Liverpool's Walton Hospital to whom Wright had remarked, 'You may think I am stupid, but I believe some evil spirit has taken control of my body. The only thing for me is death, but I am not one for suicide.' Valliant found that Wright was an aggressive psychopath, that he had a very low level of normality and his intelligence was very poor, but he answered questions put to him readily, quickly and candidly.

The main point debated in the court was whether Wright was insane as his counsel suggested, or a cold bloodied killer as the prosecution maintained. Mr H. Nelson, KC, referred to the detailed statement Wright had made which showed premeditation for the murder and the court also heard that Wright had made a number of assaults on females, but in each case the victim had refused to come forward.

The court heard of a statement Wright had made in which he recognised that he faced the death penalty for his crime and that by taking a life Wright knew he would forfeit his own. This, the prosecution alleged, meant Wright knew what he was doing was wrong and that he would be punished for it, and thus proved he was not insane.

The jury concurred and after debating their verdict for just under three hours they returned to find Wright guilty as charged and he was sentenced to death. On 3 July 1951, he was hanged at Strangeways Gaol Manchester by the country's chief executioner Albert Pierrepoint.

CHAPTER 18

HIS DAUGHTER

There was an empty desk and one name absent when schoolteacher Ruth Bleakley took the morning register at Sharples Primary School, Astley Bridge, Bolton. As her classmates made their way to morning assembly that cold Wednesday morning, 14 January 1953, they were blissfully unaware that their shy, fresh-faced classmate, six-year-old Jean Brooks, had been brutally murdered by her father at her home a few hundred yards from the school.

It was shortly after 7.15 a.m. that morning when screams brought sixty-one-year-old grandmother Esther Brooks rushing from her bedroom across the landing and downstairs to her son and daughter-in-law's bedroom in the front room of their house at 34 Hill Cot Road. She recognised the screams as belonging to her son's wife, thirty-two-year-old Rhoda Brooks. Rhoda lay slumped on the bed, her head resting on a pillow heavily soaked in blood. In the adjacent scullery, her son, thirty-year-old Ronald Brooks stood over his daughter who lay in a pool of blood on the floor.

'I have gone mad', Brooks said calmly, as his wife groggily made her way to her feet and dashed out of the front door. Esther rushed upstairs to dress and was followed by her son who asked if his daughter was dead, and told that she was, he simply replied, 'I think she is at peace now.'

Rhoda Brooks hurried to a neighbour's, Elsie Fairhurst, at 38 Hill Cot Road. Elsie could see her friend was in a very distressed state and bleeding heavily from wounds to her head. She attempted to stem the bleeding and called for an ambulance.

In the meantime, Ron Brooks had left the house and walked to Astley Bridge Police Station, where he approached constable William Ward, who was manning the front desk, and told the startled officer, 'I have done my little girl in with an axe.' Cautioned by the policeman, Brooks then added 'I have had a do at the wife too'!

Whilst detectives were sent to Hill Cot Road to follow up the confession, Brooks was taken into custody. He was then interviewed by officers from Bolton CID, and to Detective Sergeant Frank Hague he made a number of significant statements. 'How is the wife? I hit her too. Is she dead?' Told she was still alive, he then explained what he

had done. 'My nerves have been on edge for weeks and I have killed my six-year-old daughter with an axe. I have been thinking about it for a week.'

While her husband was at the police station confessing his crime, Rhoda Brooks was taken to Bolton Royal Infirmary where house surgeon Dr Jeremiah Cregan examined her. He found she was in deep shock and had suffered three lacerations to her forehead and one on her right wrist. All were bleeding profusely.

Pathologist Dr George Bernard Manning, of 8 Albert Road, carried out a post-mortem later that morning. He noted that the young girl's clothes were saturated in blood, and she had six wounds to the back and top of her head with the largest measuring a little under five inches in length. The back of her skull was shattered into twenty pieces consistent with being struck by the axe police had recovered from the scene of the crime.

At Bolton Borough Police Court a few weeks later it was heard that Brooks, dressed in a fawn raincoat and sporting rimless spectacles, had been depressed since October of the previous year and he had not been sleeping well. He had been sick recently and was receiving medication from his doctor. The session ended with Brooks being remanded into custody and committed to stand trial at the next sitting of Manchester Assizes.

When Brooks appeared before Mr Justice Gorman on Friday 6 March, his defence was insanity. When he appeared in the dock, Brooks was breathing heavily and clutching the handrail. Asked how he pleaded, Brooks stated he was guilty. This came as a surprise to his defence counsel, Mr A. M. Knight, who had been with the prisoner five minutes earlier and was under the impression that his plea would be one of not guilty. At the request of the judge, Knight spoke to his client again and a few minutes later Knight asked the court if Brooks may plead again. This times Brooks, in a barely audible voice said 'not guilty'.

Leading for the prosecution, Mr Basil Nield, KC, outlined the case and stated that Brooks, at his home in Bolton, had killed his small daughter by striking her on the head with an axe.

The main witness was Brooks' sister in law, Elizabeth Green, who shared the house on Hill Cot Road. She said that on the morning of the murder, before Brooks had gone to the police station, his eyes 'looked as if they were coming out of his head' and he had repeatedly mumbled 'I'm mad, mad, mad!'

She said that on the previous evening she had been out with Rhoda Brooks and they had returned home shortly after 10 p.m. Everyone in the house was in bed at this time and nothing her sister had said during the night forewarned the dreadful events of the following morning.

Elizabeth also told the court that her sister and Brooks had been hoping to get a council house and a few days before the murder two officials from the local authority had called at the house to interview him about the possibility of getting their own

home. Although Brooks worked as a warehouseman for the Bolton Co-operative Society, it seemed that he was worried about the financial aspects of moving house.

All witnesses agreed that Brooks had been 'very, very fond' of his daughter and there had been nothing to suggest he would carry out the dreadful crime he was standing trial for. Dr George Cormack, principal medical officer at Strangeways Gaol, had interviewed the prisoner at length during his remand and came to the conclusion that the prisoner was suffering a form of insanity. This evidence was enough to convince the jury, after just a short consideration of their verdict, that Brooks was insane. Mr Justice Gorman sentenced him to be detained until Her Majesty's pleasure be known. The charge of attempted murder of his wife, who had made a good recovery from her injuries, would remain on file.

CHAPTER 19

SUSPICIONS AND EMOTIONS

It was when he noticed the advert in the *Bolton Evening News* that his worst fears were confirmed. In the newspaper he read that a married woman, with a child of eighteen months, was looking for a flat in Farnworth or Walkden, and that was the final straw.

Derek Jeffrey 'Jeff' Simpson was born in Bolton in August 1935 and had a variety of semi-skilled jobs in and around the town before being called up for National Service on New Year's Eve 1953. He served as a gunner in the Royal Artillery both at home and overseas in Germany before being demobbed 'with good conduct' in January 1956.

Later that year, while working as a labourer on a Walkden building site, he married twenty-year-old Teresa Richardson and they moved into a house on Worsley Road, Farnworth. She gave birth to their only child in December 1957, but by this time cracks had already begun to appear in their relationship.

Shortly before the child was born the couple began to quarrel over him leaving the house untidy, and these rows escalated until Teresa moved out for a short time. During this time she sought advice from a probation officer and also spoke to a marriage guidance counsellor. She decided to return to her husband and they tried to make another go of their relationship.

Two months after the birth of their son, Teresa decided to return to work. She was employed a few miles away at Risley, and when she learned that a fellow employee, Arthur Lewis, lived close by in Norris Street, Farnworth, they began to travel to work together in his car. Gradually she began to arrive home from work much later than she did when travelling by bus and, although Simpson initially had no inkling of anything untoward taking place between the couple, he gradually began to suspect they were having an affair.

Because of the young child, Simpson and his wife were often unable to go to the cinema together, so they had a routine in which one would look after the child while the other would take in a film. This they would alternate later in the week and Simpson's suspicions were further compounded when he noticed she was returning home from the cinema much later than he did.

Teresa Simpson's notice in the Bolton Evening News *advertising for a flat for rent*

She also asked to be allowed to take the child to Blackpool for a few days, and when she returned Simpson questioned if she had been with another man. She denied it but they again quarrelled when she told him she was going out on a Saturday night and refused to tell him where she was going. He also forbade her from travelling to work with Lewis but she refused to do as he requested.

They began to row much more frequently, and, although they still lived as man and wife, gradually their relationship all but petered out and they began to live their own lives whilst sharing the house. One morning, in June 1959, Simpson watched from the window when she climbed into Lewis's car to go to work and saw she was smiling and laughing with him. That night as they lay in bed she refused to make love to him and, believing it was because of Lewis, Simpson struck her, bruising her arms. It was a few days later that he noticed the advertisement in the newspaper requesting a flat, and he also discovered a photograph of Arthur Lewis in his wife's handbag.

Simpson was heartbroken when he found that his suspicions were true and even more so when he discovered that Teresa's new address, a flat over a café just a few doors away from where Lewis lived. Simpson took to watching the flat where his wife was living and on several occasions he saw Lewis leaving.

Simpson made repeated requests for Teresa to return to him and although she did agree on one occasion, on the following day she told him coldly that it was no use trying again. On 20 July, he made what would be a final attempt at reconciliation only to be met with derision. Simpson told his mother that she had simply laughed at him 'like a school girl'.

He then learned that she had taken out a Separation Order against him on the grounds of cruelty. Simpson was at Bolton County Magistrates' Court to hear the order granted and he was ordered to pay 30s 0d per week maintenance and 10s 0d per week for the child. Teresa Simpson was also given custody of their son. When the hearing ended, Simpson went to speak to his wife only to find her climbing into Lewis's car in the carpark.

On Saturday evening, 1 August, Simpson called to his wife's flat and asked her for some things she had taken from the house, which he wanted back. He saw that she

The flat over the café on Norris Street Farnworth in 1959 and in 2009

was dressed up as if for a night out, and, believing she was going dancing at Bolton Palais, he went there but was unable to find her. He returned to Norris Street and at 11.40 p.m. he watched as Lewis left her flat. Simpson waited in the shadows looking to see if Lewis returned to her flat, but after an hour, with no sign of Lewis, he made his way home. It was then that he decided on drastic measures: he penned a number of letters in which he threatened the life of his wife, and claimed he would end his own life by gassing himself.

On the following day he decided to try to scare his wife into returning to him and, taking a knife from his kitchen he went to her flat, letting himself in with a key he had had copied from her set the week before. Entering the flat he took another knife from the kitchen in the café before climbing the stairs. He entered the bathroom and took off his shoes. Simpson then listened to see if he could hear Lewis's voice, but all he heard was his son laughing, then his wife's voice. A short time later Teresa Simpson made her way to the bathroom and as she entered he picked up a shampoo bottle and struck her with it before pulling out a knife.

'Don't!' she cried, 'I'll come home', but Simpson lunged forward and struck her with the knife. Teresa picked up another bottle from beside the sink and threw it at her husband, but it sailed past him and smashed the window. As blood began to seep through her blouse, Teresa Simpson began screaming: 'Get me a doctor, quick!' She then rushed at him and during a struggle she received further stab wounds. Simpson then fled down the stairs as she ran to the window crying for help.

He made his way to a cellar beneath the cafe, throwing the knife used to stab his wife into the corner and pulling out the kitchen knife he had tucked down the back of his trousers. He then turned the knife on himself making an attempt to cut his own throat.

The police and an ambulance were soon on the scene, and while his wife was rushed to hospital Simpson was taken into custody where he made a detailed statement, which ended with him saying, 'I love my wife more than anything else in the world and I have neglected myself to get her things. If she had come back to me when I asked this wouldn't have happened.'

Charged initially with attempted murder, Simpson was later charged with wilful murder when Teresa died from her wounds four days later, and in due course he found himself in the dock at Manchester Crown Court before Mr Justice Winn.

The prosecution was led by Rose Heilbron, QC, who stated that it was clearly a planned killing and no amount of provocation would amount to a defence under the recently passed Homicide Act, which categorised different types of murder into capital or non capital offences. Since 1957, only someone convicted of capital murder was now liable for the death penalty. Simpson's crime was deemed non-capital, but even so Mr W. G. Morris, leading for his defence, tried to get the crime reduced to one of manslaughter. Morris told the court that the provocation was, despite what the prosecution alleged, sufficient for the sentence to be reduced.

Bloodstains on the bathroom floor in the Norris Street flat

Simpson claimed he had no recollection of stabbing his wife, and his counsel submitted this was because he had been so provoked by his wife that there had been a sudden and temporary loss of self-control, which led to his wife's death.

Morris was scathing about the part Arthur Lewis, who also gave evidence at the trial, had played in the tragedy. 'I can say with confidence that Lewis was the cause of the break up of this marriage,' he told the court. 'If Lewis had not been there, the state of affairs which culminated in magistrates' court proceedings would never have taken place.' He added that Simpson was so provoked that when he was in her bathroom he finally lost control and in a moment of frenzy struck her several times and killed her.

Simpson claimed in the dock that he never intended to inflict the wounds on his wife, nor had he intended to cause her any physical violence. The prosecution countered this by claiming that when Simpson went to the flat that night he went 'with murder in his heart'. They also referred to the letters Simpson had written on

the night before the murder in which he asked that a member of the Simpson family bring up his son if he should kill his wife.

Another letter, to his mother, was perhaps the most telling. It read:

I'm crying Mam. I cry every night. I have a heart she's not. She's going out a lot with him when she was at home. I love her with all my heart she made me do it.
Goodbye

Your loving son
Jeff xxx

Summing up Mr Justice Winn made reference to the suspicions and emotions of the prisoner prior to the attack, and asking the jury to consider their verdict, they needed just an hour and nineteen minutes to find Jeff Simpson guilty of murder. Sentencing him to life imprisonment, Mr Justice Winn said that the charge of attempted suicide would not be heard but would stay on file.

CHAPTER 20

ABOUT ANOTHER BOY

Brenda Hardman had no shortage of suitors. An eighteen-year-old pretty brunette who worked both as a police typist in the court offices in Bury and a part-time waitress at the town's Prince's Ballroom, one of the young men who had been courting Brenda was William 'Bill' Horrocks, an eighteen-year-old gardener and gravedigger with Ramsbottom Corporation, who lived with his parents on Heath Avenue, Summerseat.

On Monday evening, 19 September 1960, Horrocks met up with Brenda at the ballroom where she was waiting on at the bar. He arrived shortly after 8.30 p.m., taking with him a bag of apples for Brenda along with a bag of conkers he had gathered up at work for her younger brother. During the evening, while Brenda went about her work, Horrocks drank two bottles of Guinness while he bought Brenda a ginger beer.

Brenda finished her shift at the ballroom shortly before 11 p.m. and a few minutes later Horrocks accompanied her to the 23T bus stop. They travelled on the bus towards Bolton, alighting at the stop adjacent to the Three Arrows public house, Ainsworth. They then caught a connection bus that travelled down Ainsworth Road towards Radcliffe town centre, alighting at the stop across from St Andrew's Road at around 11.20 p.m.

Brenda spoke briefly to a neighbour, Barbara Eastham, as she made her way home from the bus stop. Barbara noted later that Brenda seemed happy enough in the company of her male companion and showed no signs of distress.

As the couple approached Brenda's house on Williamson Avenue she noticed a car parked in the shadows close to her home. Brenda became scared and asked Horrocks to take its number. Telling Brenda not to worry, Horrocks approached the car and as he did so the driver, a man in his early twenties, climbed out. Ignoring Horrocks, he approached Brenda and, exchanging words with her, he climbed into the car and drove away.

Horrocks merely watched in silence and as they continued towards Brenda's house, he asked if she would meet him on the following evening. It was then she began to

Brenda Hardman

tease him about her having another boyfriend. She said she couldn't see him tomorrow as she was meeting up with a girlfriend.

'You promised I could take you to the fair', Horrocks told her. She shook her head and continued to talk about having another boyfriend, hinting that they were even engaged but she didn't want to wear a ring in front of her parents and that only her closest friends knew about it. Brenda agreed she would meet Horrocks on Thursday but that wasn't what he wanted.

'I want to see you tomorrow', he insisted.

She refused.

'Have you got someone else then?' he demanded to know.

'I might have', she teased, and at that he pulled out a putty knife he had strapped to his chest. Seeing the knife she tried to grab at him, but in an instant he stabbed her twice quickly in the chest.

As Brenda slumped to the ground fear gripped Horrocks as he realised what he had done. He began to run up the street only to stop and return to where she lay.

'Hold on Brenda, I'll get help, don't go away' he cried before rushing back towards Ainsworth Road. There was a light shining in the window of the Railway Hotel and Horrocks began banging on the door. Licencee Stanley Pollitt opened the door to be confronted by the wild-eyed teenager who barged past him shouting, 'I have stabbed Brenda, phone the police.'

Pollitt was more than used to dealing with drunks and suspecting the caller was another, he grabbed him, pushed him out onto the street and told him not to be a fool. Pollitt watched as he made is way back up Ainsworth Road towards the Three Arrows and it was then he noticed blood on his hands where he had pushed the young man outside. He then decided to call the police in case the man had indeed been telling the truth.

The police and an ambulance were soon at the scene. Brenda Hardman was rushed to Bury General Hospital but she was found to be dead on arrival. Horrocks was placed under arrest and continually cried out 'Forgive me Brenda.' Taken to the local police station he was charged with wilful murder.

A post-mortem found that cause of death had been two stab wounds to the upper breast: one had pierced a lung; the other had penetrated her heart and punctured an artery causing massive bleeding.

Williamson Avenue Radcliffe

Bloodstains on the pavements outside the house on Williamson Avenue

On the following morning Horrocks made a brief appearance in court. Sporting a crew-cut haircut and wearing a crumpled double-breasted blue suit and white shirt opened at the neck, he gripped the rail firmly and spoke just to answer his name as he was remanded in custody.

Just two months later Bill Horrocks appeared before Mr Justice Salmon at Manchester Crown Court. He pleaded not guilty and the prosecuting counsel Mr J. S. Watson, QC, told the court that Horrocks had made a statement following his arrest in which he claimed she had been teasing him about another boy. This suggested a clear motive for the crime.

The murder weapon was identified as a putty knife with a six-inch blade, which Horrocks claimed he had found in the cemetery where he was working. Earlier on the day of the murder he had shown the knife to a friend after he had strapped it to his shoulder and asked: 'What do you think of that for a weapon?' Horrocks admitted carrying the knife but claimed it was only for protection after he had been attacked on a number of occasions by gangs of 'Teddy Boys'.

Although the death penalty was still on the statute books, Horrocks' crime would not render him liable to being hanged if convicted, as he had been charged with non-capital murder, which carried only a mandatory life imprisonment if convicted. With Horrocks' guilt never in question, and with no signs of insanity, it was only a short trial and it ended later that day with the prisoner being found guilty as charged, and after sentence was passed he was led away from the dock to rue that moment of madness.

CHAPTER 21

UNWELCOME ADVANCES

Alan Kenyon led a double life. To his neighbours he was an easygoing, hard working, pleasant, free-spending bachelor; unknown to all but his closest friends, Alan was also a homosexual. By day, he was often seen out and about enjoying early-retirement at the age of just thirty-seven, but by night he frequented numerous bars and gay clubs, often taking strangers back to his picturesque cottage at 86 Lea Gate Lane, Harwood, on the northern tip of Bolton.

On Sunday 13 December 1970, a local farmer and long time friend of Kenyon's called at the cottage after Alan had failed to turn up for the usual Sunday lunch and pint at The Seven Stars, a few hundred yards away.

Approaching the cottage, he saw Alan's blue sports car standing in the drive and trying the front door he found it unlocked. 'Alan? Is anyone home?' he shouted as he stood in the porch. Receiving no reply he entered the living room and called out again. He turned on the light as the heavy drapes were still drawn, and the room was in total darkness. He walked through to the bedroom and knocked on the door.

'Alan?' he shouted and opening the bedroom door, he recoiled in horror. Lying on the bed, beneath the duvet was the body of Alan Kenyon. The white top sheet and pillows were stained a deep crimson by the blood that had seeped from a number of lacerations to the head. Lying at the foot of the bed was a heavy brass poker.

Officers from Lancashire CID, led by Detective Chief Superintendent Alfred Collins, sealed off the house and, after setting up a murder headquarters at the nearby Liberal Club, they immediately began house-to-house enquiries. Collins soon learned of Kenyon's double life and this presented him with a problem: the homosexual community were often reluctant to get involved with the police and this investigation was to be no different.

They did learn that on the night of the murder Kenyon and a friend had gone into Bolton town centre and had had a meal at the Olympus Grill on Deansgate. He had then driven to Tottington to look at a chip shop he was thinking of buying before returning home. He then went for a drink at the Black Swan on Harwood Precinct and ended the night drinking with friends at the Seven Stars.

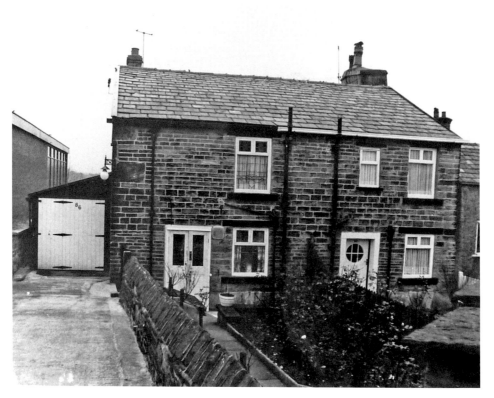

84 Lea Gate Lane Harwood

The police also discovered that Kenyon had sold a diamond watch for over £200 on the Saturday afternoon and had received £10 pounds in cash and a cheque for the remainder. A search of the house failed to locate the cheque. In the living room of the house they found three whisky glasses, a sign that Kenyon had obviously had company on the previous evening.

Police patched together the victim's last movements and learned that he was last seen in his dark blue Triumph GT6 sports car at the junction of Tonge Moor Road and Crompton Way, facing towards Bradshaw. He was returning home after dropping off a young friend with whom he had spent the last couple of hours.

On the following morning, a post-mortem was carried out by Dr Woodcock at Bolton Royal Infirmary. The doctor confirmed that the injuries had almost certainly been caused by the poker found beside the body, and it appeared that the blows had been struck while the man was lying down on the bed. There were bruises on the hands and arms, as though the victim had made a desperate attempt to fend off the attack. Dr Woodcock said that Kenyon had survived the attack for about two hours and that death was due to cerebral haemorrhage caused by repeated blows to the head and neck.

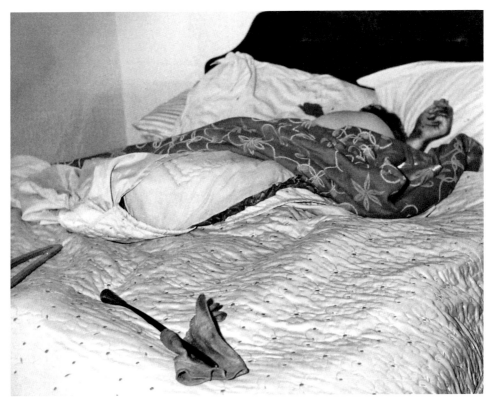

The poker used to batter Alan Kenyon to death was recovered on the bed

Police pondered the motive. It seemed at first that robbery was the probable cause, especially as the cheque was missing, but later, when the safe in the bedroom was opened, the cheque was located. Also missing from the house were two coats, and detectives believed the killer might have taken these to cover up bloodstains on his clothes.

They assumed that after having dropped off his friend, Kenyon had either picked up another man or had perhaps telephoned the killer and invited him to call. With over ninety officers assigned to the investigation, Collins concentrated on two clues taken from the house. One was a cigarette lighter shaped like an automatic pistol and the other was a white string vest. This seemed to be a major clue as it bore the nametag 'David G. Whalley'. The vest clearly did not belong to Mr Kenyon and a check on the files at the Criminal Record Office failed to turn up anyone of that name.

The nametag was the type used by institutions like the military, and officers were detailed to check through records of any likely user of such a tag. It was an enormous task and many officers were assigned to methodically work through the various organisations.

Gordon Lee as sketched in court

There were literally dozens of fingerprints in the house and when Collins learned that Kenyon was very house-proud and fond of showing neighbours around, he wondered if there was a single person in Harwood who had not been inside the house. Detectives also checked through the victim's numerous confidential telephone numbers in the hope that someone could throw light on the investigation. They didn't.

Four days after the murder, Collins and his officers had the break through they had been searching for. While enquiries continued slowly in Bolton, the trail led to Preston and an unsolved robbery from the previous springtime.

'David G. Whalley' was found to be a House Surgeon at Preston Royal Infirmary, and the vest was among a number of items he had reported stolen from the hospital laundry sometime around 6 March 1969. The description of the wanted man, and the theft of laundry at Preston, led officers to check up on the whereabouts of a convicted criminal currently on the run from Wakefield prison.

On Tuesday 22 December 1970, just when it seemed as if the officers would have to cancel their Christmas leave, they had a man in custody. Acting on information received, Detective Chief Inspector Ian Hunter of Blackburn's Number 2 Task Force called at a house belonging to twenty-two-year-old Gordon Leonard Lee on Aqueduct Street, Preston. His wife opened the door and admitted the officers. The house was searched and Lee was found hiding in a small cabinet under the kitchen sink.

'Well, you've got to try, haven't you', Lee said to the officer as he was placed under arrest. He was taken back to Bolton and under interrogation he admitted the attack.

'All right, I'll give it to you straight', he said when questioned at Astley Bridge Police Station, and continued:

> This is how it happened. I had been drinking in town and was walking up Blackburn Road where I intended to spend the night with friends. A man in a two-seater sports car stopped and offered me a lift. It was raining and I accepted. He invited me back to his house for a drink and again I accepted. He made advances and asked me to stop the night, but I didn't think anything of it at first. I had got my shirt off when he made a grab at me. I pushed him away, but he would not stop; so I hit him with the poker. When I left he was still breathing and I didn't know he was dead until I read it in the papers.

It seemed clear to detectives that Lee was probably hoping for a manslaughter charge, emphasising the provocation on a number of occasions. When questioned about the stolen coats he admitted that he had sold them, one in Buckley, the other in Blyth, Northumberland. He said that after returning to Preston he decided to 'jump ship' and fled, first to Buckley in Flintshire, where he sold one of the coats, then to North Shields from where he planned to sail to Europe. For some reason he decided to return to Preston and it was while he was at home he was arrested.

Lee, born in Downpatrick, Northern Ireland, stood trial for murder at Manchester Assizes before Mr Justice Cusack in May 1971. He pleaded not guilty to the murder of Alan Kenyon but admitted the theft of two coats. He reiterated his plea of manslaughter and the court heard how Kenyon had made unwelcome advances, which he fended off by hitting him with the poker. The prosecution's claim, backed up by medical evidence, that a number of the blows had been delivered while the man was lying on the bed seemed to contradict this account and when the jury came to weigh up the verdict, after three days of evidence, they found Lee guilty of murder.

When the judge had passed the sentence of life imprisonment, the court was told that Lee was on the run from prison where he was serving four years for aggravated burglary. He also had numerous convictions for violent crime stretching back for more than a decade.

Thus Alan Kenyon, the man whose door was always open to his friends and neighbours, died because he made unwelcome advances to the wrong guest.

CHAPTER 22

'SOMETHING SERIOUS'

Pretty redhead Annie Dick Duncan realised that trouble was afoot when she saw her estranged husband standing at the bus stop close to her home in Armstrong Street, Horwich. Forty-two-year-old Annie, who worked as a copy typist at Bolton Town Hall, had been divorced from her husband, forty-six-year-old George Duncan, an engineer's labourer at Horwich Loco Works, in January 1980, but although Duncan moved out of the matrimonial home in Horwich into a house on Hartington Road, in the Heaton area of Chorley New Road, he was still a regular, if unwanted, visitor to the house. In desperation, that April Annie got a restraining order against Duncan preventing him from calling on her.

Although they were now divorced, Duncan was still jealous of his wife, and when he became convinced she had a new lover he was enraged. On Friday 27 June, he called at the house while Annie was at work and spoke to their eighteen-year-old son about his former wife's new relationship. Whatever words passed between father and son was not reported, but when Duncan returned to work that afternoon he told a workmate he was in a rage.

'I'll do her in yet, so help me', he said, adding that he was going for a drink and to see a probation officer that afternoon. During the talk with the probation officer Duncan reiterated his threats to kill his wife, adding that he had served in the army and that 'I know how to do it'!

These threats were apparently not taken too seriously as nothing was seemingly reported to the police. At 7.30 p.m. that night Duncan was seen out drinking, telling a friend he wanted looking after as he was going to do 'something serious'. That 'something serious' did indeed happen a short time later when Duncan made his way to Armstrong Street, clutching a bottle of cider.

He had already made one visit to the street an hour or so earlier when his former wife had seen him at the bus stop. When she got back home she reported what she had seen to her son and that she had a 'funny feeling' and that something was disturbing her. Her son had plans for the evening and shortly before he left he turned to his mother and told her to 'make sure you keep the door locked'.

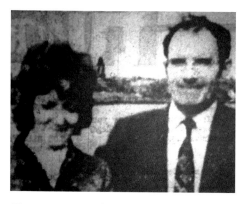

Above: *Annie and George Duncan*
Below: *Innocent victim John Wood*

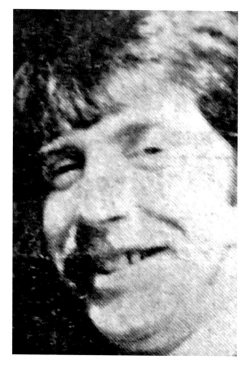

When Duncan re-appeared at Armstrong Street later that evening, Annie wasted no time in calling for help. Jack Wood lived close to Armstrong Street on Chorley New Road, Horwich, and it was he who heard her call for help. Along with his thirty-two-year-old son John, Jack Wood went to the back gate of his house and heard Annie ask him to call the police saying that her husband was not supposed to visit her. John Wood went to see what was happening and could only watch as Duncan approached Annie and stabbed her in the stomach with a knife. Wood hurried to give assistance and a scuffle broke out between the two men, which ended when Wood received a fatal stab wound to the heart.

By the time the police arrived John Wood was already dead and although an ambulance hurried Annie to hospital, she too succumbed to her injuries within the hour. Taken into custody Duncan was still in a rage shouting, 'I don't give a **** what happened to him, but I hope I have killed her.'

John Wood, an innocent victim in the tragedy, was not the man having a relationship with Annie Duncan and had simply been in the wrong place at the wrong time that fatal night, visiting his father and step mother. He was described as popular man, who worked as an engineer for British Rail, and left a widow and three young children.

Questioned later that night George Duncan admitted he had taken the knife into work and had sharpened it before using it to commit the murder, but added he had 'no reason to stab that man'. At his trial before Mr Justice Caulfield at Manchester Crown Court on 13 November the background into the events leading up to the murder were told to the court. They heard that Annie had fled her original home in Edinburgh taking her son with her, seeking refuge from her husband. Their travels

took them across the country, via Bristol, Reading, Burnley and London, 'dragging her suitcases' as she called it. Their son described Duncan as being 'like a schizophrenic' and that he could be nice sober but was terrifying when drunk.

Duncan had served in the army during the Korean War, during which he had been wounded, and he had later sold the medals he had been awarded to buy drink when short of money. With a daughter settled in Edinburgh, Annie and her son moved south to Lancashire finally settling in Horwich. Duncan joined them in an attempt to save their marriage and found work in the Loco Works. This happy reunion was to last just six months. Duncan began violent assaults on his wife, and, after she briefly fled to the Lakes for a short time, she returned to Horwich and took steps to end her marriage.

His defence counsel, Charles Mantell, QC, told the court that Duncan had killed the person dearest to him and a man he did not know and against whom he had no grudge. 'He expresses very real remorse', Mantell told the jury.

Remorse or not, it was a wicked crime that took the life of two innocent people and Duncan was duly sentenced to life imprisonment.

CHAPTER 23

WHILE DOING HIS DUTY

It had been his childhood ambition, almost a burning desire, his parents said, to be a policeman. When he was refused entry into the force at the age of sixteen, after leaving Farnworth Grammar School, he was frustrated but did not give up. Two years later, and now hoping to follow in the footsteps of his childhood friend David O'Brien by joining the Greater Manchester Police Force, John Egerton kept his application and interview a secret from even his parents until he returned to the family home in Buttermere Road, Farnworth, one afternoon in November 1979, declaring proudly to his mum, dad and two sisters, 'I'm a Bobby!'

Following a successful spell at the police training college he was posted to his local area of Farnworth, and by the spring of 1982 Egerton, a few months shy of his twenty-first birthday, was now approaching the end of his probationary period.

In the early hours of Thursday 11 March 1982, twenty-five-year-old Police Constable David O'Brien was on routine foot patrol near the Moses Gate area of Farnworth when he spotted a man in a check lumber jacket scaling the gates of Dynamic Plastics on the junction of Egerton Street and Emlyn Street. O'Brien radioed for assistance and moments later he spotted the panda car driven by friend and colleague Police Constable John Egerton arrive at the scene. After a quick discussion the officers entered the factory yard and split up.

It was a dark night and within seconds the officers lost sight of each other. Moments later O'Brien received a call from Egerton saying he had spotted the intruder, but when, a few minutes later, O'Brien radioed his colleague for an update, he received no reply. O'Brien tried the radio again then retraced his steps across the yard where he was horrified to stumble across the stricken body of his friend lying beside a vehicle.

Police Constable O'Brien immediately summoned for assistance on his radio and by his flashlight he could see a pool of blood below his friend's head. He turned him over and saw that there seemed to be no sign of life and that John Egerton appeared to be already dead.

Scores of police hurried to the scene and sealed off the area, but the intruder had already made good his escape. Paramedics tried in vain to resuscitate the officer and

Dynamic Plastics Egerton Street Farnworth, where the young policeman was brutally slain

although an ambulance hurried him to Bolton General Hospital the young policeman was found to be dead on arrival.

Daylight revealed a number of clues. Close to where Police Constable Egerton's body had been found, detectives, under the command of Detective Superintendent Cyril Barstow, head of Bolton C.I.D., recovered his radio, truncheon and broken wristwatch, but more significantly they found a number of containers and a length of hosepipe. It seemed clear that the young officer had interrupted someone siphoning petrol from vehicles in the factory yard. Later that morning the suspected murder weapon, a five-inch sharpened carving knife, was found next to a waste skip in the factory yard of Egerton Mill in nearby Phetean Street.

A post-mortem, carried out by Home Office pathologist Geoffrey Garrett, found that the six-foot tall officer had been stabbed several times to the head and chest and that the fatal wound, probably the last of the blows, had penetrated through his clothing, between the fifth and sixth ribs, and had penetrated his heart. Death, due to massive haemorrhaging following the wound to the heart, would have been almost instantaneous. The pathologist also told detectives that the fatal blows would have been wielded with 'a hard force' and that it had almost certainly been a deliberate action.

A shocked Police Constable O'Brien was able to give detectives a good description of the man he had seen climbing the factory gates as detectives began door to door enquiries at the houses on and close to Egerton Street, an area in which many of the houses were boarded up ready for demolition.

Shocked workers reporting for the day shift at Dynamic Plastics found the area swarming with police who set about a murder enquiry at first light. Amongst the first of the neighbours that detectives spoke to was Mrs Mary Edge, who lived on Egerton Street, adjacent to the scene of the crime. She told the officers that the single-story factory had been the subject of a number of break-ins over recent weeks, and that vandals had been plaguing the area since it was earmarked for demolition. Also quickly on the scene were journalists from both local and national newspapers, and Mrs Edge kindly supplied officers and reporters with cups of tea as the hunt for the killer swung into action.

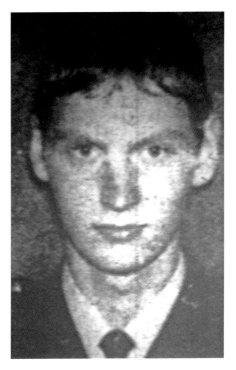

Police Constable John Egerton

As officers combed the murder scene, a suspect was already in custody. Off duty Police Constable Critchlow was making his way along Manchester Road at 7 a.m., when he spotted someone matching the description of the wanted man. He called for back up and police detained the man as he passed Burnden Park, the site of the Bolton Wanderers Football Club.

The man gave his name as Arthur Edge, aged thirty-six, who lived with his girlfriend on Egerton Street, across from where Police Constable Egerton had been murdered. Unemployed Edge, with an IQ of only sixty-six, already known to the police as someone who carried a knife and who possessed a criminal record, with convictions for theft and driving whilst disqualified, was taken to Castle Street police station to await questioning.

Edge was the son of Mary Edge who, while her son was in custody, had been making officers cups of tea. He told detectives that he hadn't been in the area at the time of the murder as he and his girlfriend had quarrelled and he had left the house and had been 'roaming around'. When this version of events was disputed and unsupported, Edge then tried to pass the blame onto his stepson who he claimed 'always has a big screwdriver on him to force off petrol caps'.

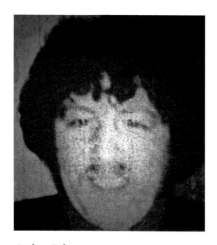

Arthur Edge

Edge was held on suspicion, when a number of cans identical to those found at the scene of the crime were found at his home, and as he was driven into custody in Manchester he broke down and told detectives the truth of what had happened. Edge said coldly how he had been disturbed while siphoning petrol from a van and heard the officer say, 'You are under arrest.'

'He grabbed me by my sore wrist and I brought the knife up, and I think I missed…' Edge continued, 'He just would not let go. I don't know how many times I stabbed him — I had to get away and he would not let go. Even when he was on his knees he would not let go.'

John Egerton's funeral drew massive crowds who lined the streets paying their respects to watch his coffin on its last journey. Across the country flags flew at half-mast at police stations and tributes to the young officer flooded in to the family home. James Anderton, chief constable of Greater Manchester police, said that John had been 'marked out by his honesty and integrity', and his lifelong friend Police Constable O'Brien, himself reaching the end of his probation period, said that John's death had made him want to be a policeman even more.

In September 1982, Arthur Edge found himself in the dock at Liverpool Crown Court before Mr Justice Farquharson. He pleaded not guilty. Prosecuting counsel Mrs Helen Grindrod outlined the facts of the case then referred to a statement Edge had allegedly made in which he claimed that after the officer had grabbed him he had made to resist. In the statement Edge claimed he had the knife in his hand when the officer tried to detain him.

'I had the knife in my hand — it was only when he pulled me towards him that I stabbed him' the statement read. Mrs Grindrod told the court that Edge had also claimed that he had only punched the officer, although he did admit to be holding the knife at the time.

When Edge was called to the stand he broke down and sobbed uncontrollably. Holding the bible aloft he started to take the oath and managed the words, 'I swear by almighty God…' before becoming overwhelmed and, covering his face with his tattooed left hand, he was offered a glass of water and the chance to regain his composure, before it was decided to have a short adjournment.

Once the evidence had been heard the jury were asked to consider their verdict. They needed just an hour and a quarter to return a unanimous verdict that Arthur Edge was guilty of murder. Passing sentence of life imprisonment, with a recommendation he serve a minimum of fifteen years, Mr Justice Farquharson said the verdict was

'absolutely inevitable' and that the murder was 'an act of overwhelming brutality in cutting down a young police constable in the threshold of his career'. The judge added that 'the act of brutality was matched only by the officer's bravery and determination'.

Members of Police Constable Egerton's family broke down and wept as Edge was ushered below to the cells. The murdered officer's mother told reporters that she felt compassion for Edge's mother who she felt must feel awful at the tragic events, but in the case of her son's killer she was more forthright:

> They should hang him; he has taken somebody's life. I know the courts will not bring back the death penalty for John's killer, but I think the longer the sentence the better. It might just deter someone else from doing a horrible thing like this.

In December 1983, Police Constable John Egerton was posthumously awarded the Queen's Commendation for Brave Conduct and the Greater Manchester Police Force commissioned The John Egerton Trophy, awarded each year to the most courageous act of valour by an officer in the Greater Manchester Police Force.

Arthur Edge served just eighteen years for the brutal murder of the young officer and was released in 2000.

CHAPTER 24

PERSON UNKNOWN

The large Victorian detached house at 27 Bromwich Street, Bolton, had stood empty for a short time and needed some renovation before it could be made habitable again. Tenant John Baxendale, a forty-nine-year-old painter and decorator was in the cellar checking out the best way to tackle this part of the house when his Alsatian dog began to sniff at a bundle of rags in the corner. With no electricity, Baxendale was using candlelight, and on closer inspection he found himself looking at what he thought was a tailor's dummy. It was only when he pulled the dummy out that he found himself looking at a decaying body, the head of which rolled free at his feet. He gathered it up, placed it in a carrier bag and took it to nearby Castle Street police station. It was Tuesday 14 December 1982.

Under the command of Detective Superintendent Cyril Barstow, Head of Bolton CID, a murder investigation was set up when the 'dummy' was found to be the body of a woman. Pathologist Cyril Woodcock carried out a post-mortem but due to the decomposition of the body he could only be vague in his estimation as to the age and its general characteristics.

Woodcock found that she was Caucasian, and would have been between 4 feet 8 inches — 4 feet 10 inches tall, but he could only guess that her age was anything between twenty-one and forty-five years of age. From a tuft of hair it was thought she had been a brunette and a row of upper dentures recovered from inside the skull was broken. This suggested she may have met with a violent end, but beyond this he was unable to say what had caused her death. Further investigation into the denture found traces of glue, which had been used to repair it, which seemed to dismiss it being damaged during an assault.

Detective Inspector Derek Stringer was put in charge of the investigation and soon found one significant clue. It seemed that the woman had been sleeping rough in the cellar in a bed made up of cardboard and old newspapers. The most recent newspaper beneath the body was a copy of the *News of the World* dated Sunday 13 March 1966, which seemed to date her death a bit more accurately.

The body, which detectives named 'Mary Ellen' was dressed in clothes popular in the 'swinging sixties'. These included a pair of brown stretch slacks, a turquoise pullover with orange hoops, a mustard coloured cardigan and pink bra and pants.

27 *Bromwich Street Bolton* *The modelled head of the 'person unknown'*

She was also wearing a gold eternity ring and clutching the broken remains of a rosary necklace featuring the Madonna and Child on a copper crucifix. There was no trace of her shoes, but a woman's handbag was found close by.

Investigating a possible murder carried out some sixteen years before posed something of a problem for the detectives. Many of the houses on and around Bromwich Street had been converted in student flats serving students studying at Bolton's two technical colleges and, with over a decade and a half having passed, scores of people would have come and gone in the flats during this time. The cellar could be accessed by a set of stone steps from the outside, so it was possible that the woman could have been a vagrant or someone sleeping rough and had no link to any of the residents but all previous occupants were traced and one by one they were eliminated. They also learned that the owner of the house during the mid-1960s had since died so that line of enquiry soon came to an end.

Fingerprint expert Detective Chief Inspector Tony Fletcher was called in from Manchester to see if he could take prints from the handbag, but although skilful work managed to lift a number of them, finding a match on file proved unsuccessful, as

were attempts to trace the makers of the broken dentures. Photographs of the rosary and eternity rings appeared in the newspapers but both were found to be mass-produced items and there was nothing to trace when they had been made or from where they had been purchased.

As each line of enquiry was exhausted, the detectives decided to recruit the help of Richard Neave, the assistant director of Manchester University's Department of Medical Illustration. Neave had experience of constructing the plaster of Paris and clay heads, and facial reconstruction, in the past and agreed to help to construct one to see if a likeness could solve the mystery. The head was then constructed, matching up the bones found in the cellar and using plasticine where there were missing parts, using a formula created by scientists in Russia many years before to calculate the shape of the features from the bones and shape of the skull. When this was completed detectives contacted Ruth Quinn, deputy head of the make up department at Granada Television Studios in Manchester, who worked on programmes such as *Stars In Their Eyes*, and she was asked if she could apply make-up as the woman may have worn in the 1960s.

Once this had been completed the reconstructed head was featured prominently on television and in the press, but again it failed to bring any clues as to the identity of the woman.

As no women reported as being missing during 1966 matched the remains found in the cellar, officers reasoned she was perhaps from overseas. This area of town was popular with people from Ireland, and although enquires took place across the sea, these too came to nothing and gradually the investigation had to be scaled down.

At Bolton Town Hall, on Friday 23 April 1983, coroner David Blakey presided over an inquest. With no evidence as to the identity of the body he recorded an open verdict and the person unknown was released into the custody of social services, who arranged for her burial in a pauper's grave.

FURTHER READING

Murderous Bolton
Steve Fielding
ISBN 978-1-84868-309-9
Price: £12.99

Available from all good
bookshops or order direct
from our website
www.amberleybooks.com

OTHER TITLES BY STEVE FIELDING

The Hangman's Record Volume One
 1868-1899
Lancashire Murder Casebook
The Hangman's Record Volume Two
 1900-1929
North Wales Murder Casebook
Cheshire Murder Casebook
Yorkshire Murder Casebook
The Hangman's Record Volume Three
 1930-1964
Lancashire Tales of Murder & Mystery
Pierrepoint: A Family of Executioners
Hanged at Durham
Hanged at Pentonville
Hanged at Liverpool
Pierrepoint: A Family of Executioners
The Executioner's Bible
Hanged at Manchester
Murderous Bolton
Hanged at Leeds
Hanged at Birmingham
Hanged at Winchester